W9-CGX-198

BARRON'S ART HANDBOOKS

ANATOMY

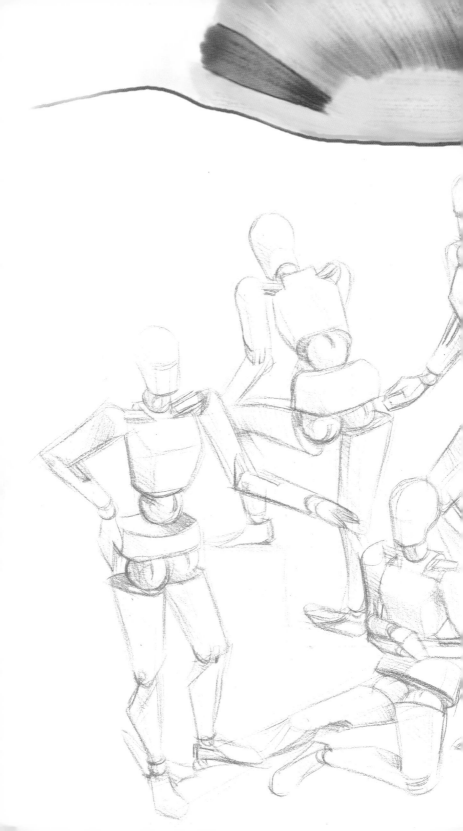

BARRON'S ART HANDBOOKS

ANATOMY

BARRON'S

CONTENTS

THE HISTORY OF ANATOMY IN ART

• **The Art and Science of Anatomy.** Science and Art. Anatomy and Nudes. *Anatomy and Pictorial Styles* 6–7

• **Anatomy Throughout History.** The Nude as a Model for Art. The Nude in Asian Art. Anatomy prior to Greece. *An Esthetic Wager* 8–9

• **Anatomy and Greek Art.** Anatomy in the Ancient World. Classical Greece. Art Based on the Human Body. *Idealized Anatomy* 10–11

• **The Greek Canon.** Creating a Canon. The Canon of Polyclitus. Stylization of the Canon. *Adaptations to the Canon.* 12–13

• **The Renaissance.** Dissections. Artists and Anatomists. The Anatomy of Vesalius. *Art and Science* 14–15

• **Anatomy and Proportion.** Studies of Proportions. Art Academies. *George Stubbs and the Anatomy of the Horse* 16–17

• **Anatomy in Our Time.** The Revolt Against Academia. Anatomy and Avant-garde Art. Anatomy's Validity in the Modern World 18–19

PROPORTIONS, MUSCLES, AND BONES

• **Proportions of the Human Body.** The Canon prior to the Greeks. The Western Model. Development of the Canon. *Other Systems of Proportion* 20–21

• **Skeletal References.** Identifying Muscles and Bones. The Skeleton. Articulations. *Depicting the Skeleton* 22–23

• **References to Muscles.** The Nature of Muscles. Mechanics and Disposition of Muscles. *Muscles as an Expression of Energy* 24–25

• **Anatomy of the Head.** Bones of the Head. Muscles of the Head. Muscles of the Neck 26–27

• **Drawing the Head.** The Shape of the Head. Layout of the Face. The Process of Drawing. *Anatomy and Drawing of the Head* 28–29

• **Using an Articulated Mannequin.** Three-dimensionality. Types of Mannequins. Articulation. *A Three-dimensional Sketch* 30–31

• **The Torso.** Bones of the Torso. Articulation and Relief in the Thorax. Muscles of the Torso. Relief in the Torso. *The "Esthetic Armor"* 32–33

• **Laying Out and Drawing the Torso.** Three Sections. Graphic Construction. The Female Figure......... 34–35

• **The Back.** Bones of the Back. Muscles of the Back. *The Lumbar Aponeurosis* 36–37

• **Laying Out and Drawing the Back.** Laying Out the Back. Drawing Muscular Relief. *The Muscles that Wrap Around the Shoulder* ... 38–39

• **The Hips.** Bones of the Hips. Muscles of the Hips. *The Ischial Position* 40–41

• **The Arms.** Bones of the Arms. Articulation of the Forearm. Muscles of the Arms. *Pronation and Supination* 42–43

• **Drawing the Arms.** Parts of the Mannequin's Arms. Drawing the Muscles. Articulation of the Elbow. *Muscles as Cords* 44–45

• **The Legs.** Bones of the Legs. Muscles of the Legs. Adduction and Abduction. *The Popliteal Hollow and the Shape of the Femur* 46–47

• **Laying Out and Drawing the Legs.** The Shape of the Legs 48–49

• **The Hands.** Bones of the Hands. Muscles of the Hands. *Drawing the Hand* 50–51

• **Drawing the Hands.** Laying Out the Drawing. Developing the Subject. Streamlining and Finishing 52–53

• **The Feet.** Bones of the Feet. Muscles of the Feet. *Position of the Malleoli* 54–55

• **Drawing the Feet.** Feet Planted on the Ground. Colored Drawings. Shading. Shadows and Colors.... 56–57

• **The Spinal Column.** Vertebrae. Movements of the Spinal Column 58–59

TECHNIQUE AND PRACTICE

• **Studies in Balance.** The Importance of Balance. The Line of Gravity. The Support Surface. *Intuitive Calculation* 60–61

• **Studies in Movement.** Axes of Movement. *Contraposto.* Three Horizontal Axes. Vertical Axes 62–63

• **Laying Out the Pose.** Axes of Movement and Proportion. Layout Models. Straight Lines and Curves. *Geometrical Drawing* 64–65

• **Sketches of Movement.** Rapid Sketches. Visual Memory. Quick Layout. Photographs. *Rhythm of Line* 66–67

• **Academic Anatomy.** Academy Figures. Usual Techniques. Other Techniques. *Chiaroscuro Style* 68–69

• **Light and Anatomical Relief.** Light and Shadow. Types of Illumination. Selecting Illumination. *Background Illumination* 70–71

• **Selecting a Pose.** Repose. Action. Open and Closed Poses. *The Profile* 72–73

• **Layout and Shaping of Anatomy.** Paper and Charcoal. The Drawing Process. Blocks of Shadow. Shading . . 74–75

• **Line and Color in Anatomical Drawing.** Materials. Initial Areas of Color. Applying Pigment with a Brush. Finishing the Process 76–77

• **Anatomy and Line Drawings.** Abstraction. Length of Lines. Width of Lines. The Final Product. *Simplicity of Line* 78–79

• **Anatomical Drawings Using an Artist's Pen.** Colored Inks. Format and Technique. Developing the Work. Finishing the Drawing. *Light and Shadow* 80–81

• **Studies in Light and Shadow (I).** A Basic Study in Charcoal. The Initial Shadows. Depicting Shapes. Nuances 82–83

• **Studies in Light and Shadow (II).** Layout. Initial Shading. Anatomical Details. *Charcoal in Anatomical Drawings* 84–85

• **Shaping the Anatomical Features.** A Complete Anatomical Study. Proportions. Preliminary Shading. Shaping the Features. *Divisions and Proportions* 86–87

• **Anatomy and Chiaroscuro.** Outlines. Shadows. Contrasts. Chiaroscuro. *Anatomy and Baroque Chiaroscuro* . . . 88–89

• **Harmony in Anatomical Relief.** A Good Preliminary Sketch. Washes. Modeling. Finishing the Work. *Watercolors and Anatomical Studies* 90–91

• **Light and Color in Anatomy (I).** Pencil Drawing. Color Contrasts. Harmonizing. Finishing. *Color of the Paper* 92–93

• **Light and Color in Anatomy (II).** Pictorial Synthesis. Coloring. Modeling and Adjusting the Color. *Anatomy and the Atmosphere of the Nude* 94–95

THE ART AND SCIENCE OF ANATOMY

In theory, anatomy is a scientific discipline. Artists have traditionally
used sources of medical knowledge to learn about the
muscles and bones of the human body.
Artists and scientists have long collaborated in
investigating the internal features of the human body to apply
this knowledge to their respective fields.

Science and Art

Here is a dictionary definition of anatomy: "the science that concerns itself with the structure, the location, and the relationships among the different parts of bodies." This same dictionary also specifies what is intended by artistic anatomy, and defines it this way: "The arrangement of the external members that comprise the body." Scientific anatomy and artistic anatomy. To what extent does the latter depend on the former? Does an artist need to know scientific anatomy?

Art and science follow different paths. Just the same, there was a time when the problems of both disciplines came together on common ground, and science and art collaborated to produce major advances in knowledge. This occurred in the Renaissance, a time when there was no idea,

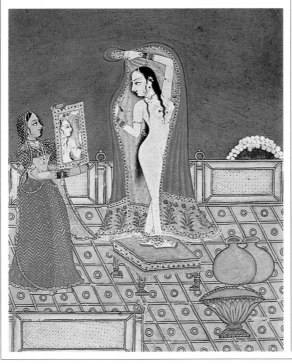

Boundy School. After the Bath. *Allahabad Museum (India). Persian and Indian miniatures show a refined esthetic sense, but their concept of the nude has little in common with the anatomy depicted in Western art.*

Anatomy and Pictorial Styles

Starting in the Renaissance, all European art schools adopted classical models as a reference and accepted the discipline of anatomy as a basis for depicting the human body. This did not keep local schools from developing their stylistic peculiarities and talented artists from applying a personal touch to their knowledge of anatomy. The same can be said for current artistic production, which is distinguished by a long tradition of anatomical drawing.

no matter how sublime, that could not be expressed through the nude body. Humanists took it upon themselves to show painters the secrets of human proportions and anatomy: science, art, and technique converged.

Nowadays there is scarcely any common ground between art and the sciences, but the human figure is still the center of all sculpture, and anatomy is the best means to understanding the organization and the movement of the parts of the body. Even though an understanding of anatomy alone is not enough for artists to create beautiful illustrations, it still has to be present in the back of their minds, for ultimately it is crucial to their work.

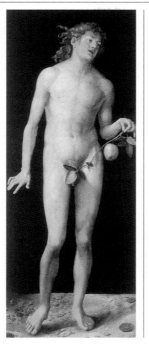

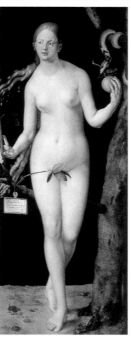

Albrecht Dürer. Adam and Eve. *Prado Museum (Madrid, Spain). In the Renaissance, concepts of anatomical accuracy and physical beauty gave rise to enduring types of human body models.*

Anatomy and Nudes

A knowledge of anatomy is of interest to artists primarily because it allows them to resolve the difficulties that male and female nudes present. Anatomy implies a theoretical and practical knowledge of the body's proportions, and as a result, it becomes essential to both drawing and painting all types of figures, whether clothed or not. An understanding of anatomy allows an illustrator to sketch a correctly proportioned figure in a couple of strokes and to complete a painting of a figure without falling victim to the typical distortions that characterize beginners. Further, anatomy is extremely useful in drawing from memory, without a model, because the artist has formulated a complete mental picture of the muscular relief that makes it possible to depict every attitude and gesture without having to refer to external reality. This is very useful in conceiving scenes and trying out compositional possibilities before beginning a large work.

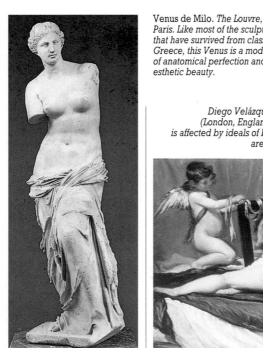

Venus de Milo. *The Louvre, Paris. Like most of the sculptures that have survived from classical Greece, this Venus is a model of anatomical perfection and esthetic beauty.*

Diego Velázquez. Venus of the Mirror. *National Gallery (London, England). Even a realistic painter like Velázquez is affected by ideals of beauty that, beginning in the Renaissance, are associated with a knowledge of anatomy.*

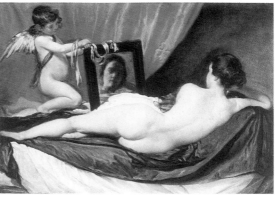

ANATOMY THROUGHOUT HISTORY

The study of human anatomy has captivated artists at different times in history. Those times are comparatively brief. For centuries, painters worked without precise knowledge of anatomy. There is an artistic ideal uniting art and anatomy that holds the human body as the undisputed center of plastic creation and the highest ideal of beauty.

The Nude as a Model for Art

The intense dedication of the great artists from all periods of history has converted the nude into a type of formal model in every kind of plastic and architectural construction. It is certainly not by chance that the formalized body of the "perfect person" has been converted into the supreme symbol of European, pagan, and Christian faith from Greek art all the way down to our time. Just the same, if we limit the history of Western art to the approximately four thousand years that separate us from the creations of ancient Egypt and place the birth of modern anatomical science in the Renaissance, we see that scientific anatomy occupies a period of scarcely

five hundred years; in other words, an eighth of this slice of time. No one could seriously maintain that artists have known what they are doing only in the last five hundred years, and even less that artists who lived before this time period could have produced "more correct" works if they had been acquainted with scientific anatomy.

An Esthetic Wager

Today we can see clearly that anatomy, in the modern sense of the word, supposes more than a proof of artistic correctness: it is an esthetic wager based on the classical concept of beauty. This is the formula of anatomy in art: anatomical science vivified by the ideal of classical beauty. It is a wager that remains in force; even today, the nude is still a way of affirming faith in ultimate perfection and in the beauty of the human form.

The Nude in Asian Art

In Indian, Chinese, and Japanese art, nudes were never a recurring subject to the extent that they were in classical European art. In any case, the nude body never had such a symbolic value as it did in the Western world. The relatively uncommon representations of nudes are

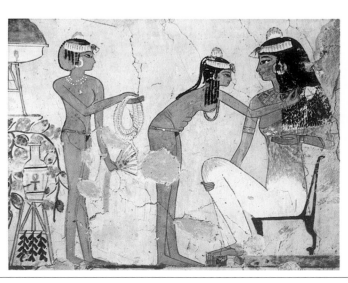

Lady's toilet. *Tomb of Jeserkaraseneb, Thebes (Egypt). In this painting, ignorance of anatomy is not the point, but rather a stylized decoration applied to the figures. Egyptians probably were familiar with human anatomy, but their art had purposes other than realistic representation.*

Balkis, Queen of Sheba. *Fragment of a Persian miniature. British Museum (London, England). In Asian art, anatomy occupies a very subordinate role to ornamental beauty and elegance of line.*

Anatomy prior to Greece

There are plenty of figures in the art of the great civilizations of Mesopotamia and Egypt that show a perfect mastery of anatomical representation, even though they are subjected to stylizing that distances them from the realism that characterizes European art. Nearly all the figures are based on a stereotype that is constantly repeated, except in representations of kings and pharaohs, who are given more imposing proportions. This art is more symbolic than realistic, and it is intended to transcend the immediate expression of physical beauty.

not a display of harmonic beauty, but rather a means of expressing sensuality. Despite the nonexistent interest in anatomy conceived in the Western way, figures in Asian art offer a graphic quality that is in no way inferior to the great manifestations of plastic art from the European Renaissance and Baroque periods.

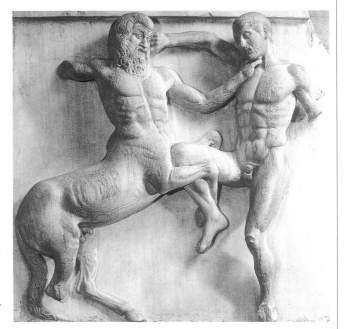

Lapita and Centaur, *ca. 440 B.C. Metope from the Parthenon. Acropolis Museum (Athens). Classical Greek art established the anatomical ideal in Western art, and it is a source of interest for artists because of its anatomy.*

ANATOMY AND GREEK ART

We do not know how well developed the science of anatomy was in Greece, but there has been no artist with comprehensive knowledge of anatomy in the centuries that followed who has presented a more faithful version of human anatomy than that embodied in the statuary of classical Greek art. Most of the principles that shaped European art date from that era.

Anatomy in the Ancient World

It is difficult to determine the origins of anatomy, seen as a science, in the ancient world. It is possible that Hippocrates (the most famous doctor of antiquity) dissected some cadavers, but there is nothing that suggests a systematic knowledge of anatomy.

Whether or not the Greeks knew the configuration of the internal organs of the human body, they not only achieved perfect anatomical correctness, but also established the anatomical ideal for European art.

Most authors agree that it was possible to accomplish this independently of any scientific anatomical knowledge, and that it was the product of a stylistic evolution

Idealized Anatomy

Perfection in realistic anatomical representation and idealization of form go hand in hand in Greek art. When Greek sculpture attained its classical splendor, anatomical forms remained as established models of refined esthetic quality: the hands, head, feet, waist, knees, and every part of the body serve as models of artistic perfection. As proof of that, today some art institutes continue to use classical fragments of anatomy reproduced in plaster as models for drawing classes, along with reproductions of the most famous statues from antiquity.

that stretched from the Archaic to the Classical period, and of observation of nature.

Classical Greece

The astonishing evolution of Greek art started with Asian and Egyptian influences around 600 B.C. and developed a series of figurative styles that led to the wonderful art of classical Greece around 400 B.C. At that time there arose new types of architecture, sculpture, and painting that were to revolutionize art history.

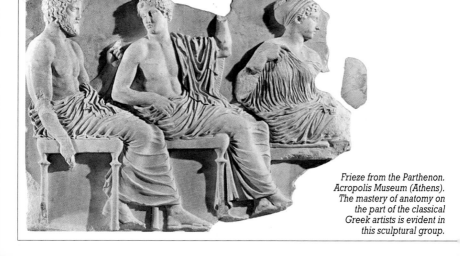

Frieze from the Parthenon. Acropolis Museum (Athens). The mastery of anatomy on the part of the classical Greek artists is evident in this sculptural group.

The rapid process of evolution in Greek art runs from the Archaic era (from the eleventh century B.C. to the start of the fifth century B.C.) to the Classical period (480–330 B.C.). Archaic art began with symmetrical, frontal representations of human figures, in a style practically identical to the sculpture of ancient Egypt, and it evolved to the point of naturalism, thanks to the gradual accumulation of correct details produced by observing reality and working from flesh-and-blood models. These "corrections" introduced by ancient Greek artists on the basis of archaic, formalized, and inexpressive precedents, are unparalleled in the history of art.

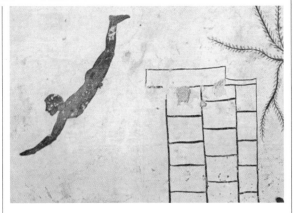

Boy Diving. Paestum Museum (Italy). Greek artists created naturalistic representations filled with vitality owing to their knowledge of anatomy.

Art Based on the Human Body

Unfortunately, no great Greek pictorial work has survived to our day. What we know about the painting of Greek artists we owe to the enthusiasm of Roman historians. Still, we know that there was an intense and varied production of free painting (that is, not applied to useful objects) centered on murals and on wood and mortar panels. Ceramic decoration leads us to believe that these painters enjoyed total liberty of composition: the figures perform free and natural movements, and every one responds to its own typology (young, old, athletic, stout, and even deformed characters). Greek art is realistic and based entirely on natural forms, on the correct sizing of the limbs of the body, and on natural movement by the figures—in other words, on human anatomy.

MORE ON THIS SUBJECT

- The Greek Canon, **p. 12**

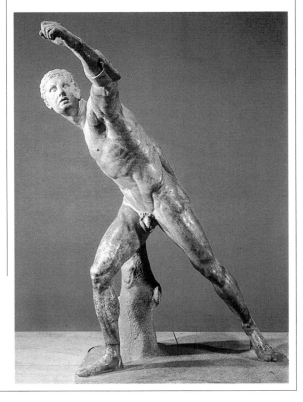

Fighting Warrior. Louvre (Paris). Works like this display a knowledge of anatomy used to communicate vigor and physical strength.

THE GREEK CANON

The anatomical perfection of the figures in classical Greek art is inextricably linked to a canon of proportions. Even though there were systems of proportions in previous historical periods, the Greek canon established the guidelines for acceptable anatomical representation in the European art that followed.

Creating a Canon

It is possible to follow the progress in Greek figures step by step from their origins in archaic sculpture through the most refined works of the Hellenic period. The figures that characterize the Archaic period are the *kurós*: figures of nude youths in a conventional and symmetrical pose, with the fists clenched against the hips and one foot ahead of the other. The facial features are schematic and characterized by a stylized, conventional, and inexpressive smile.

A similar situation occurs with female figures, or *koré*: they are little more than mere supports to hold up the clothing that hangs in symmetrical folds.

At the beginning of the Classical period, the structure of the Archaic period is maintained: frontal pose, symmetry, and one foot ahead of the other. Nevertheless, the figures now appear relaxed, with the weight of the body resting on one foot, the hip cocked, and the body slightly curved; these look more like flesh-and-blood bodies.

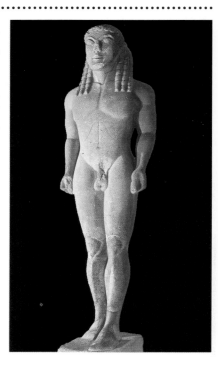

Statue from the sanctuary of Apollo in Delphi (Greece). Figure belonging to the Archaic era of Greek art; the anatomy is still schematic.

Youth Exercising.
Painted ceramic. The disproportion apparent in this figure is the result of a very evident decorative purpose.

The Canon of Polyclitus

In 440 B.C., during the full Classical period, the sculptor Polyclitus created the first canon of human proportions: the *Doryphoros*. Polyclitus wrote a treatise on this subject entitled *Canon* (rule or formula). Polyclitus established a height of eight heads for a figure, which supposes a robust and well-built model. The canon of Polyclitus also involves relationships among the different parts of the body: between the fingers of the hand, between the hand and the forearm, between the forearm and the upper arm,

and so forth—all based on anatomical reality and observation of a real figure. This

Adaptations to the Canon

The existence of a canon did not obligate all artists to follow it. It was just as important as observing a system of proportions, or even more important, to achieve an expressive representation of vitality. There are many such representations in ceramic decoration where the canon is superseded by the artist's unfettered fantasy.

position remains in effect even today in academic art schools when the human figure is studied and drawn.

Starting with Polyclitus, figures in Greek art move naturally and adopt particularly harmonious poses with the counter position of the shoulders and hips. The foot planted on the ground produces an elevation in the corresponding hip, while the shoulder on the same side slopes downward.

Stylization of the Canon

Around the year 320, the sculptor Lysippus proposed a new, more slender canon

using the principle of eight heads in the type of sculpture known as *Apoxyomenos*. His figures broke definitively with the frontal pose by making the shoulders rotate opposite the direction of the hips. With the arrival of the Hellenistic period (late fourth century B.C.), the freedom of movement in the figures is total. This liberty can be seen very clearly in ceramic painting. Motivated by their desire for elegance and slenderness, the painters normally applied the eight-head canon, but they sometimes used nine heads and even more, and they demonstrated a complete mastery of the anatomy of movement.

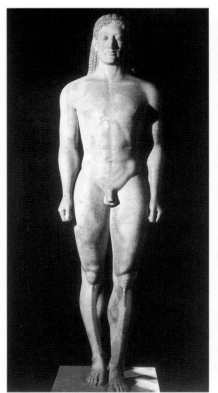

Funerary statue from the south of Attica. Athens National Archeological Museum. Starting with its Archaic origins, Greek sculpture evolved to incorporate greater naturalism.

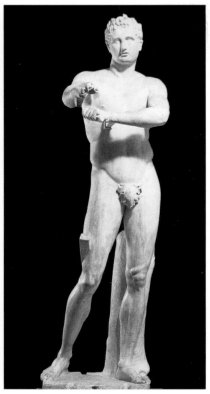

Apoxyomenos, the work of Lysippus. With this statue, the distinguished sculptor of Alexander the Great proposes a new eight-head canon that is more slender and endowed with graceful movement.

THE RENAISSANCE

The extraordinary emphasis placed on anatomy in Italy (specifically in Florence) during the fifteenth century was the product of passionate curiosity applied to the study of all kinds of things from classical antiquity. Florentine illustrators took an interest in the measurements of the human body, the precise topography of the muscles, and the means of creating expression and movement.

Dissections

The vast majority of Florentine artists in the fifteenth and sixteenth centuries based their work on the study of the nude body. Pollaiuolo (1433–1495), Leonardo (1452–1519), and Michelangelo (1475–1564) used dissection to arrive at definitive preciseness. Consequently, at the end of the fifteenth century there were many painters who found satisfaction in displaying their recently acquired knowledge by illustrating figures with their body flayed ("sacks of nuts," as Leonardo called them). This preoccupation spread far and wide, and extended to studies of nudes underneath clothing and the skeleton beneath the nude as preparation for any kind of painting.

Artists and Anatomists

Painters and sculptors were not pursuing a scientific goal, but they were using a systematic inclusion of anatomical details in their works that was the product of their observation and that they hoped would be appreciated and used by specialists. The main artistic purpose was to demonstrate that it was possible to attain a degree of excellence comparable to that which was visible in the remains of ancient monuments that constituted the canon of beauty. Works were judged not only on the basis of the beauty of the drawing and color, but also on the correctness of proportions and anatomy.

Andreas Vesalius. Engraving from the work Humani corporis fabrica. *The illustrations of the great anatomical treatise by Vesalius, in a wonderful Renaissance style, are the best demonstration of the intimate link that existed between art and anatomical science.*

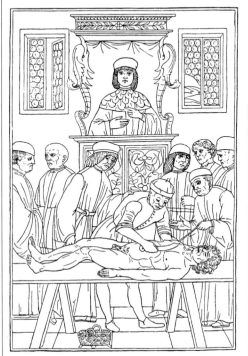

Scene of a dissection from the book Medical Installments, *Venice, 1493. At the end of the fifteenth century, dissections were a common practice in Italian universities.*

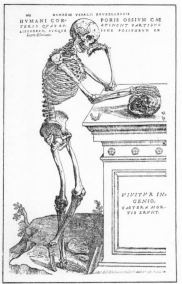

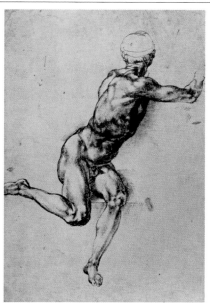

Michelangelo. Study of a Figure. Royal Library, Windsor Castle (Windsor, England). Michelangelo turned muscular relief into a means of expression of the highest magnitude, and he placed anatomy in the center of focus for esthetic interest for several generations of artists.

Art and Science

Artists and scientists have very different outlooks. Where a scientist sees anatomical correctness, an artist can also see an interesting combination of lines and shapes and a perfect interplay of proportions. Ever since the Renaissance, this is what painters and sculptors have seen in the art of antiquity: a truly artistic anatomy. Even though the fields of art and medicine are totally liberated today, we cannot forget that the Greco-Roman model served as a common pattern for medical anatomists and sculptors for a long time.

The Anatomy of Vesalius

Precise anatomical engravings with pretensions to objectivity became very widespread beginning in the sixteenth century. The book *Humani corporis fabrica* by Andreas Vesalius (1514–1564) was published in 1543. Vesalius was the most celebrated anatomist of the Renaissance. This work openly criticized the ancient artists and proposed a systematic anatomy based on careful dissections. The engravings that illustrate Vesalius' book are artistically of the highest order. It has been asserted that the originator of some of them was none other than Titian, but it is more probable that the person responsible was the engraver who prepared the plates of the numerous paintings of the great Venetian artist for distribution. Despite their purely scientific purpose, the illustrations in the book depict skeletons and flayed figures in theatrical poses and gestures typical of the era, or in poses common to the statuary of antiquity.

Antonio Pollaiuolo. The Abduction of Diana (fragment). Jarves Museum (New Haven, Connecticut). Pollaiuolo was one of the first artists to practice dissection—a very risky practice at that time, since it was strictly forbidden by law.

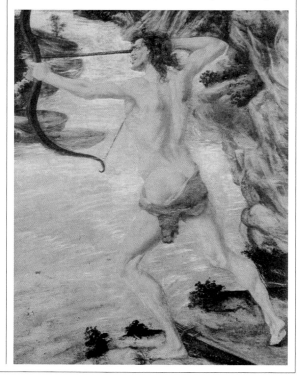

ANATOMY AND PROPORTION

In parallel with anatomical investigation, Renaissance humanists and artists carried out a broad spectrum of inquiries focused on systems of proportions for the human body. This was an issue that affected painters and sculptors as well as architects, since all beauty in construction is derived from the beauty of the human form.

Studies of Proportions

During the Renaissance, analysis of the relationships among length, breadth, and thickness of the various components of the body had led to all kinds of templates and precepts for construction. They were difficult to apply, but they gave an illusion of having uncovered the secrets of an ideal beauty. One of the consequences that came from an effort to join anatomical knowledge with an ideal of human proportions was that of models arranged in various quadratures or blocks, which have been used in art academies every since. The indisputable usefulness of these models shows that a knowledge of anatomy is of no use to artists unless they also have a clear conception of human proportions.

George Stubbs and the Anatomy of the Horse

The particular case of the English painter George Stubbs (1724–1805) speaks eloquently of the relationship that existed between art and anatomy in the eighteenth century. Stubbs, who specialized in painting horses, created magnificent engravings of this animal's anatomy. His purpose was to call attention to his work, and coincidentally, to gain intellectual credibility in a time and a society vitally interested in scientific revelation. With his *Anatomy of the Horse* he achieved a renown unattainable through illustrations of human anatomy, which was a familiar specialty that everyone assumed to be at the command of any competent artist.

Art Academies

In the eighteenth century academies for the fine arts were established throughout all of Europe; most of them had a distinctly national character and were directed by the absolute monarchies of the corresponding countries. This was also the era of illustration and of rationalism, and the rapid development of medical science rendered obsolete the idealized anatomical images of the old treatises that were always accompanied by the accustomed frontispieces, inscriptions, and moralizing scenes. Ultimately anatomical

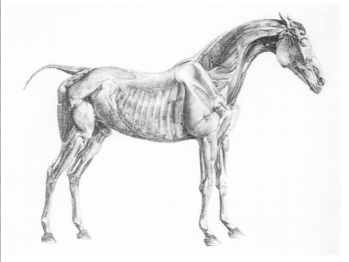

George Stubbs. Engraving showing equine anatomy. The Royal Academy of Arts (London). Stubbs' studies of horse anatomy unite scientific precision and a fresh artistic sense. This freshness had been lost in illustrations of human anatomy.

Leonardo da Vinci. Vitruvian Man. Gallery of the Academy (Venice). The title of this famous illustration refers to Vitruvius, the great Roman writer of treatises on classical architecture. Leonardo, among many other artists of the Renaissance, tried to reconcile human proportions with the principles of harmony put forth by Vitruvius.

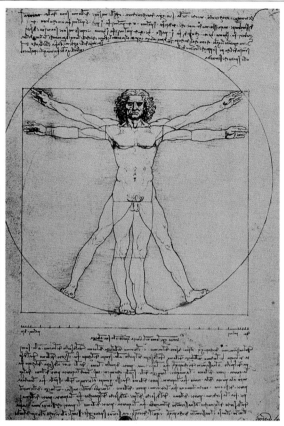

illustration was relegated to a purely didactic function, and it renounced its application as a model for artists. Medical and artistic anatomy took different directions. At that time the first anatomy manuals for exclusive use by painters and sculptors appeared. They were limited to images of skeletons and flayed figures in "artistic" poses inspired by the statuary of antiquity. There were statues of flayed bodies in all the workshops and academies of the eighteenth century; the most famous one was by Houdon, which was copied thousands of times by students in the nineteenth century.

Jacques Louis David (1748–1825). The Oath of the Ball Game. National Museum of the Château (Versailles, France). David was the major exponent of academicism in the eighteenth century. The anatomical figures, which are consummately done, almost become a cliché without a thematic justification in a work that depicts real people with total verisimilitude.

ANATOMY IN OUR TIME

The crisis in academic art instruction, brought on by Impressionism and aggravated by the appearance of the historical avant-garde movements, removed anatomy from the privileged place it had occupied in art instruction ever since the Renaissance. The art of our time—ever changing and unpredictable—seems to leave little room for anatomy.

The Revolt Against Academia

The artistic preeminence of the nude as the focus of plastic art achieved its peak in the modern world during the Renaissance. This emphasis was vigorously maintained during the Baroque, Neoclassical, and Romantic eras. The esthetic revolution of Impressionism, with its interest in daily life and its disdain for academic norms, set the hierarchy of artistic themes on its head, relegating the nude to the status of just one more subject among many others and elevating landscape to a preeminent position.

The avant-garde movements of the twentieth century further radicalized this rebellion against the academies. It challenged not only the traditional artistic themes, but also the very nature of graphic representation.

Anatomy and Avant-garde Art

Cubist painting opened a progressively abstract road that led many painters to a nonfigurative type of art in which forms and colors do not

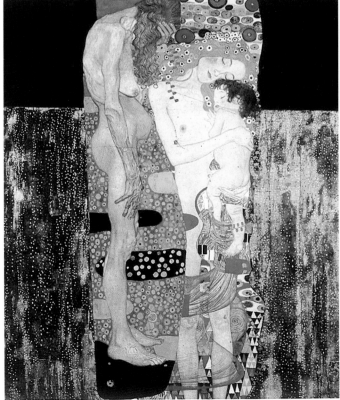

Gustav Klimt. The Three Ages of Woman. National Gallery of Modern Art (Rome). A perfect knowledge of anatomy is concealed behind apparently arbitrary exaggerations in the representation of these bodies. In the hands of modern artists, anatomy is a tool for expression in service to individual sensitivity.

Teresa Llácer. Nude. Private collection. Beneath the chromatic and compositional innovations that contemporary art has produced there still pulsates a profound sense of anatomy.

represent real objects and figures. It is reasonable for academically expanded anatomy to have no interest for these painters. Just the same, many other artists have continued working with nudes and have brought this theme to different areas than the traditionalists did.

These new concepts unchained the creative energy of young European artists, who now felt greater freedom to innovate, invent new combinations, and create more daring and personal works.

Movements such as Futurism in Italy, Cubism in France, Expressionism in Germany, Neoplasticism in Holland, and Suprematism in the Soviet Union were successive avantgarde manifestations that proclaimed the artist's total liberty and the liberation of art from subjugation to traditional academia.

Anatomy's Validity in the Modern World

The human figure has ceased to be the thematic focus of contemporary artistic creation, and anatomy is no longer the essential and indisputable discipline that many people who are not familiar with present-day art might suppose. Nor is a knowledge of anatomy the useless anachronism that some artists believe. When we contemplate

modern and contemporary works in which the human figure is still the center of attraction, it is easy to see that anatomy is still present, implicitly or explicitly, interpreted using objective will or recreated according to an artist's personal vision. Ignoring this fact would be tantamount to denying the evidence that anatomy is inseparable from any type of representation of the human form.

Esther Olivé. Nude. Private collection. In a departure from classical proportions, contemporary artists work out personal interpretations of anatomy.

PROPORTIONS OF THE HUMAN BODY

For any form in nature, it is possible to locate various systems of proportions based on the feature of the form that is considered to be fundamental (its height, breadth, or the dimensions of its parts). This is also true for the human figure. Anatomy in art is linked to a system of human proportions inherited from the ancient Greeks.

The Canon Prior to the Greeks

It is clear that the proportions of figures from Asian art and sculpture from African tribes are different from those of a Greek sculpture.

Egyptian artists had their own system of proportions for depicting figures.

According to recent studies, the basic measurement was the clenched fist and the breadth of the hand, and the squares of the grid were based on this fundamental unit. The head was the equivalent of three units; from the shoulders to the knees, there were ten units, and from the knees to the sole of the feet, there were six. The measurements were complicated by divisions and subdivisions corresponding to the fingers, which incorporated measurements that were nearly as miniscule as millimeters.

The Egyptian system of proportions, which was based entirely on the relationships among the parts of the human body, was mankind's first attempt to endow its pictorial representations with a pattern or model of artistic perfection, and it was to have a decisive influence in the Greek conception of a universal system of human proportions.

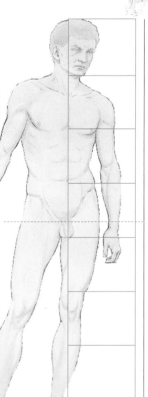

Scheme of proportions for the male figure.

The Western Model

Western culture's roots go back to classical antiquity, and that is the source for the concept of proportions. According to this concept, the size of the head in relation to the body determines the pattern by which we evaluate other proportions in nature. A system or canon of proportions establishes a relationship between the height and the width of the body

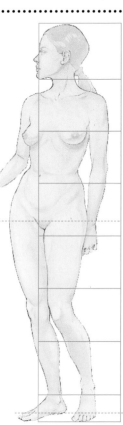

Scheme of proportions for the female figure.

and the dimensions of the head. The idealized classical canon dictates a height of eight heads, but the following canon is a bit closer to reality: seven and a half heads for adult figures, and between four and six for children and adolescents.

Among the many possible patterns, this is one of the most useful ones in creating well-

proportioned drawings of figures without exaggerated stylizing. Our artistic anatomy is adapted to this system or general framework of relationships among the parts of the human body.

Development of the Canon

The Greek canon is a complete system of proportions: it affects not only the height of the figure, but also the rest of the measurements of every part of the body. As a result it is possible to develop a general principle and apply it to the tiniest detail of the figure. Our sense of human proportions is based on this notion of harmonious relationships among

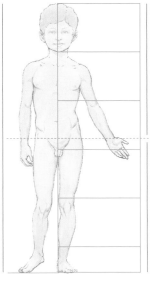

Scheme of proportions for a child between ten and twelve years old.

all the parts of the body. At the same time, anatomical correctness is more than locating the muscles and bones in the right places; it also involves depicting them in a set of proportional relationships that produces an organic unity that is pleasing to the eye.

Starting with the Renaissance, many artists and theorists proposed various canons that modified the classical proportions in the interest of greater elegance or slenderness. In any case, every painter and sculptor adjusted the classical norm to personal stylistic requirements.

Other Systems of Proportion

During the Renaissance, the wish to discover the "secrets" of ancient art and thoughts led many artists to create different systems of proportions holding the key of beauty in art. Albrect Dürer devoted a lot of effort in search of the geometrical ratio of human proportion. Many other scholars of that time came forward with various models, some very ingenious, complex, and harmonious, and some as stylized as the ten-headed canon that you see at the right.

Illustration from the book of Juan de Arce y Villafante De varia conmesuración *for sculpture in architecture, Sevilla, 1585.*

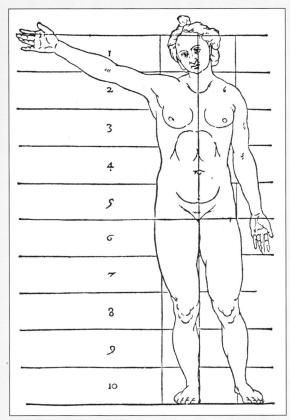

SKELETAL REFERENCES

Anatomy involves studying the bones and muscles of the body. In the following pages we will place special emphasis on the ones that are relevant to drawing, that is, those that are visible under the skin, with the figure either in repose or in motion. It is very important for readers to try to locate and identify in their own body the bones and muscles that are mentioned here; sometimes that is very easy, but at other times, there is no alternative to trusting the anatomical explanation.

Frontal view of the skeleton showing the characteristic joints and articulations

Dorsal view of the skeleton

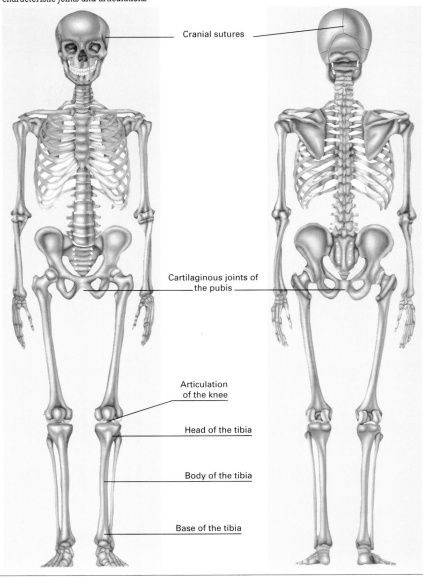

Cranial sutures

Cartilaginous joints of the pubis

Articulation of the knee

Head of the tibia

Body of the tibia

Base of the tibia

Identifying Muscles and Bones

Even though practically everyone knows the names of bones such as the tibia, the fibula, the scapula, and the clavicle, it is important to know precisely where each of these and many other bones are located. That is the only way that an artist will be able to identify and understand what can be seen in the relief of a nude body, and that is a prerequisite to drawing it correctly. It will also be worthwhile for the reader to copy the illustrations on the following pages as an effective way to understand and remember the shape and the position of the muscles and bones, thereby developing skill in depicting the human figure.

The Skeleton

The skeleton is the bony, jointed structure that holds up the human body and supports and protects the internal organs. Nearly all of the 233 bones that comprise the skeleton are jointed and can be moved by the muscles. Most of the bones are present in pairs to the left and right of the body's line of symmetry. The bones that form an exception to this rule, such as the cranium and the vertebrae, are made up of two similar halves.

Depending on their shape, the bones are divided into long ones such as the humerus and the tibia, and flat, broad ones such as the scapula and the pelvis. There are also short

Depicting the Skeleton

In old anatomy treatises, illustrations of skeletons were presented in poses of classical statuary. Today artistic poses are still used to make it easier to locate the bones. This is an example of the close connection that exists between art and the field of anatomy.

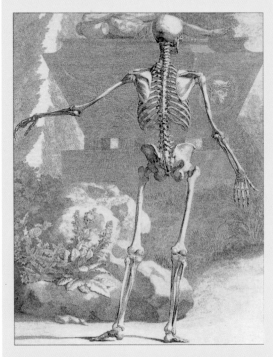

Engraving from the anatomical treatise Albinus Tabulae Sceleti et musculorum Corporis Humani, *Leyden, 1747. The Victoria and Albert Museum, London. Classical anatomical engravings keep the memory of classical Antiquity alive in the poses of the skeletons and the flayed bodies.*

and irregular ones such as the vertebrae and the bones of the wrist and the ankle. Long bones usually serve as the axis of the limbs and consist of a semicylindrical or prismatic part known as the body, and of two enlarged extremities with surfaces that are adapted to articulation. Flat bones are shaped like a plate with faces, edges, and angles. Short bones have a more or less cubical shape and also have faces and edges.

Articulations

Bones join one another at joints that may be either fixed or movable. Fixed joints may be held together by sutures, as in the bones of the cranium, or by cartilaginous tissues, such as in the pubis. In the movable joints, the bones mate at their extremities, and their union is reinforced by ligaments.

MORE ON THIS SUBJECT

- References to Muscles, **p. 24**
- The Torso, **p. 32**
- The Spinal Column, **p. 58**

REFERENCES TO MUSCLES

The number of muscles varies between 460 and 501, depending on how they are counted by different anatomists; many muscles can be considered to form a single unit or an aggregate. They overlap one another and are arranged in layers or planes. The muscles of the internal organs and the motor muscles located in deep layers are not visible in relief on the outside of the body, which is the view that is of interest to artists.

The Nature of Muscles

Muscles are fibrous formations that make it possible to move the bones. They are connected to the bones by tendons and ligaments, and they are divided into long muscles (in the extremities), broad muscles (which impart movement to the trunk), short muscles (capable of developing greater strength), and annular muscles (which surround the body's orifices). In reaction to nervous impulses, the muscles contract and shorten; they stand out more and move closer to their insertion points in the joints.

In general, the names of the

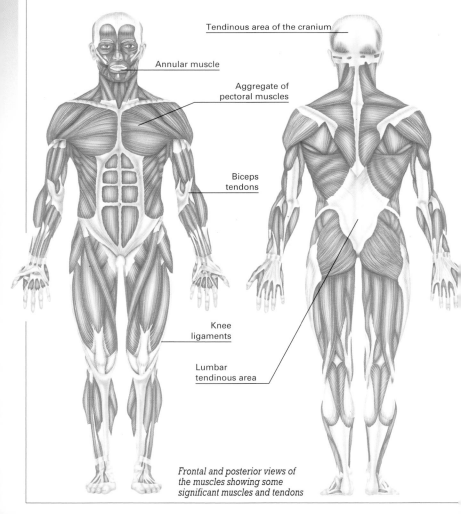

Tendinous area of the cranium

Annular muscle

Aggregate of pectoral muscles

Biceps tendons

Knee ligaments

Lumbar tendinous area

Frontal and posterior views of the muscles showing some significant muscles and tendons

muscles are related to shape, location, and function. So muscles designated as *oblique*, *pyramidal*, and *straight*, for example, owe their name to their characteristic shape. The ones that are designated as *pectoral*, *dorsal*, and *sacro-spinal* refer to their location. Function is also the basis for naming muscles, such as *pronator*, *supinator*, and *flexor*.

Mechanics and Disposition of Muscles

The muscles that can be moved voluntarily are composed of transverse muscle fibers. These fibers are held together by tendons, sinewy bands, or tendinous partitions. The muscles are covered by a sheath that turns into one or more tendons at its extremities.

The mechanics of muscle movement are governed by laws that are identical to those that control the movement of a lever: the muscle exerts a force to overcome resistance (the weight to be moved or lifted), and the joint serves as a fulcrum for the system. In the illustration, the fulcrum or support point is located in the elbow.

The human body has many more muscles than the ones that can be seen under the skin at a glance. The muscular system is composed of several superimposed layers; the muscles in the deep layers have no direct bearing on the external relief of the body. As a result, this book will focus only on the muscles of the superficial layers that are important for illustration purposes.

Muscles as an Expression of Energy

A familiarity with the mechanics of muscles has been a tremendous resource for many artists in expressing vigor and energy. The muscular tension and torsion produced by movement is translated into a rich interplay of lines and tonalities that gives life to certain drawings and paintings.

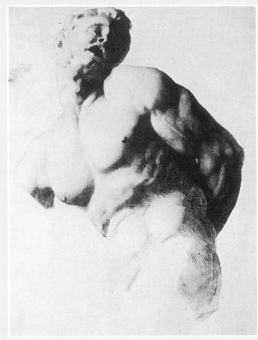

Georges Seurat: copy of a sculpture by Pujet.
Private Collection (Paris)

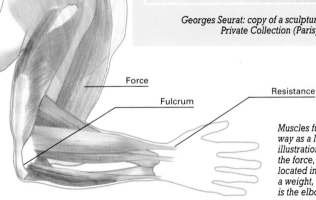

Force

Fulcrum

Resistance

Muscles function in the same way as a lever. In the illustration, the biceps exerts the force, the resistance is located in the hand that holds a weight, and the fulcrum is the elbow.

ANATOMY OF THE HEAD

The head is composed of a multitude of small muscles and bones. Most of the bones are connected by sutures so that they are immobile, with the sole exception of the lower jaw. The many muscles correspond to physiological needs such as chewing and vision, as well as laughter and sadness, plus the countless gestural possibilities of the human face.

Bones of the Head

The head is comprised of twenty-two bones, of which only the lower jaw is movable. The bones of the head are divided into the bones of the cranium and the bones of the face. The most important cranial bones are the *frontal* (the forehead and the eye sockets), the *parietals* (the cranial vault), the *occipital* (the cranial base), and the *temporals* (on both sides of the cranium, beneath the parietals). The most significant bones of the face are the *maxilla superior*, the *maxilla inferior* (the mandible), the *malar* (which determines the relief of the cheeks), and the *nasal bone*. From the viewpoint of anatomy in art, the morphology of the head suggests the form of an egg when seen from the front or the side, and it appears more spherical when seen from behind.

Muscles of the Head

The cranium has but two muscles: the *temporal* and the *occipital*, which are located on top of the bones of the same name. The face, on the other hand, contains many small muscles that perform multiple movements of closing (blinking, moving the lips, etc.), expression, and chewing. The most significant ones are the *frontal* (moving the forehead), the *superciliary* (eyebrows),

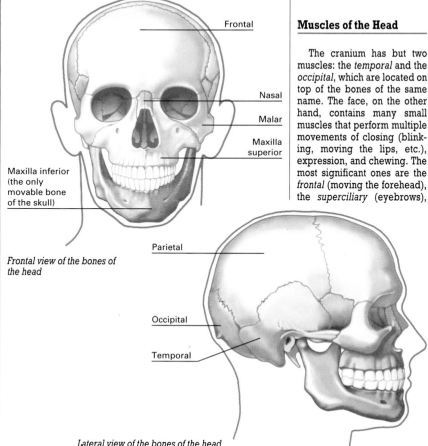

Frontal

Nasal

Malar

Maxilla superior

Maxilla inferior (the only movable bone of the skull)

Frontal view of the bones of the head

Parietal

Occipital

Temporal

Lateral view of the bones of the head

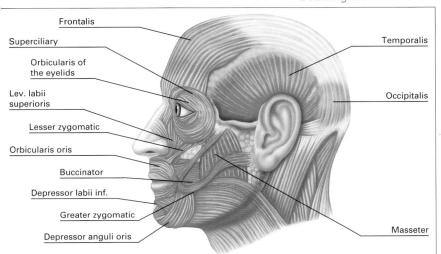

Frontalis

Superciliary

Orbicularis of
the eyelids

Lev. labii
superioris

Lesser zygomatic

Orbicularis oris

Buccinator

Depressor labii inf.

Greater zygomatic

Depressor anguli oris

Temporalis

Occipitalis

Masseter

Lateral view of the muscles of the head

the *orbicular* of the eyes, the *masseter* (chewing motion in the mandible), the *depressor labii inf.*, the *orbicularis oris*, and associated muscles (the zygomatics, the buccinator, the *lev. labii superioris*, and the *depresor anguli oris*).

Muscles of the Neck

Seen from the front, the neck presents a neck line or a V-shaped cavity between the two clavicles that is the juncture of the sternocleidomastoid muscles, which originate behind the ears. Between the two muscles and in the upper part of the neck is the hyoid bone, which articulates with no other bone and is supported by the hyoid muscles. Part of the larynx known as the laryngeal prominence or Adam's apple sticks out from among these muscles, espe-

cially in men. The splenial muscles stand out at the side of the neck; they are partially obscured at the bottom by the trapezius muscle and by the sternocleidomastoid in the upper part. All these muscles are completely covered by the cutaneous muscle, which provides unity and continuity to the shape of the neck.

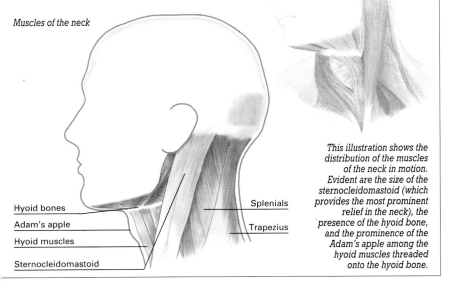

Muscles of the neck

Hyoid bones

Adam's apple

Hyoid muscles

Sternocleidomastoid

Splenials

Trapezius

This illustration shows the distribution of the muscles of the neck in motion. Evident are the size of the sternocleidomastoid (which provides the most prominent relief in the neck), the presence of the hyoid bone, and the prominence of the Adam's apple among the hyoid muscles threaded onto the hyoid bone.

DRAWING THE HEAD

The shape of the skull has a direct influence on the exterior appearance of the head. The size of the muscles and ligaments is minimal in the lower jaw, the cheeks, the forehead, and the scalp, and it is the bones of the skull that give shape to the face. In order to create a good drawing of the head, you have to begin by establishing the shape of the skull.

The Shape of the Head

Seen in profile, the human head can be reduced to the form of a sphere, to the lower part of which is added the schematic triangle of the mandible. The mandible is arranged in such as way that it protrudes slightly from the vertical line that marks the extremity of the sphere, and with respect to this imaginary vertical line, it creates an extension toward the outside. By calculating this line visually, it is possible to place the features of the forehead, the nose, and the chin on it. The distances between these features must be the same: the distance from the upper part of the forehead to the origin of the nose, from that point to the base of the nose, and from the base of the nose to the point of the chin must all be the same. As the head is viewed from the front, the basic shape of the sphere is slightly modified and flattened at the sides.

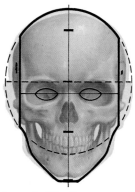

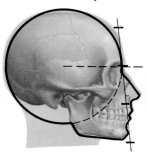

Seen from the front, the circumference of the skull appears flattened on the sides.

The basic shape of the skull is a sphere from which the triangle formed by the chin protrudes.

Layout of the Face

The shape of the face is determined according to its central line or axis of symmetry. Along this are situated the origin and the base of the nose, the eyebrows, the eyes, and the lips. In order to situate the features approximately, you can use the eyebrows as a point of reference; they are located at the center of the sphere that gives the head its shape. This spherical shape of the head makes it possible to imagine it in any position, turning from right to left or from top to bottom. Both the horizontal and the vertical circumference (the line of symmetry of the face) will maintain their relative positions in each of these rotations, making it possible to figure out the location of the eyes, eyebrows, nose, mouth, and ears in any position of the head.

The Process of Drawing

In practice, drawing the head is based on the correct understanding of the sphere that determines the general shape, and on the proper location of the facial features along the axes mentioned earlier. The relationship between the general shape of the

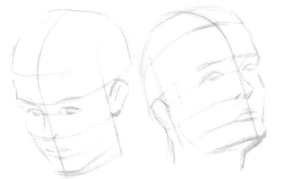

A drawing of the head and facial features is deduced from partitions laid out on a spherical shape. These partitions indicate the location of the features on the sphere's line of symmetry.

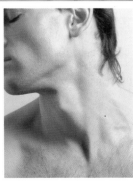

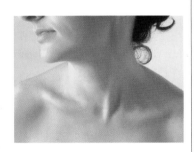

These photos (especially the one of the man) highlight the characteristic muscles of the neck.

A drawing of the neck under tension is always determined by the strong relief provided by the sternocleidomastoid muscle, and in the case of a man, by the laryngeal prominence or Adam's apple.

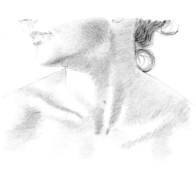

skull and the size and location of the features is the key to a good illustration. Once this relationship between the proportions has been resolved, all that remains to be done is fine detailing based on careful observation of the model.

Anatomy and Drawing of the Head

The bony structure of the skull is particularly noteworthy in people of advanced age. An adequate knowledge of anatomy is a great help to illustrators and painters in doing this type of portrait. Knowing anatomy makes it much easier to draw the head of an elderly person than that of a person of any other age. A good understanding of the shape of the skull can contribute greatly to the accuracy of a drawing in both its anatomical and physiognomical features.

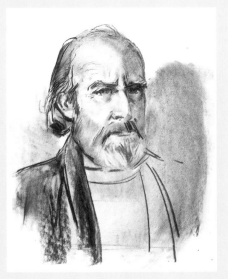

All the details of a portrait can be done with precision once the basic shape of the head is established. Work by Vicenç Ballestar.

USING AN ARTICULATED MANNEQUIN

An articulated mannequin is a figure composed of simple pieces of wood. It is a traditional tool in academic anatomical drawing that makes it possible to recreate most of the movements of the human body. It is a great help in doing anatomical drawings without a model, and in drawing figures in general.

Three-dimensionality

A mannequin is a three-dimensional representation of a human figure. It serves as a model of human anatomy using simple forms that represent the basic parts of the body. By copying its component parts, you can immediately achieve a useful model and flesh it out with the true contours of the figure, in other words, the characteristic anatomical relief. The parts of the mannequin facilitate this. Since they are basic simplifications of anatomy, they are very useful in laying out the dimensions and proportions of the various body parts.

Good quality mannequins have joints that make it possible to reproduce most movements of the human body and make them appear natural.

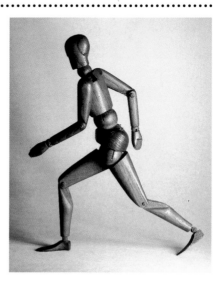

Types of Mannequins

Articulated mannequins are available in all stores that deal in supplies for fine arts. They come in different sizes and qualities and are made from various grades of wood. Most of them fill their pedagogical need well as long as you do not demand too much of them; practically none of them is capable of duplicating all the movements of the human body, especially the movements that involve very pronounced flexions of the torso and the limbs. Only more complex mannequins of large size and prohibitive price tag have a system of joints that make it possible to imitate all postures of the body. These large

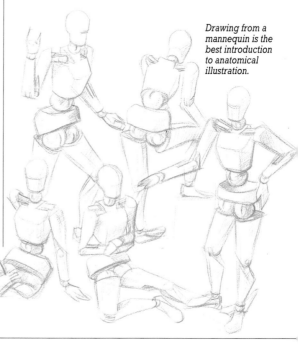

Drawing from a mannequin is the best introduction to anatomical illustration.

mannequins were first used in the eighteenth century in the most important art academies, and they can still be seen in some fine arts schools.

Articulation

Many mannequins have a support that helps keep them on their feet; however, if the mannequin is of good quality, it should be able to remain upright using nothing more than its own legs. Usually it is the upright poses that look most natural in mannequins; the more bends there are in the joints, the harder it is to achieve a pose that corresponds to reality. Often this problem is resolved by using nylon thread to tie one part to another and force the articulations.

The advantages of working from a mannequin include the following: on the one hand, it is possible to draw figures without recourse to a living model; on the other, the mannequin facilitates practicing with the basic shape of human anatomy by copying some schematic parts. Once you have achieved the necessary facility, it is a good deal easier to transform these sketches into realistic illustrations.

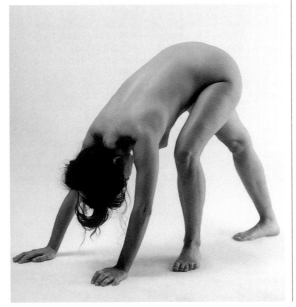

A photographic reference is the point of departure for drawing anatomical features with the aid of a mannequin.

MORE ON THIS SUBJECT
- Laying Out and Drawing the Torso, **p. 34**
- The Hips, **p. 40**
- Drawing the Arms, **p. 44**

The parts of the mannequin make up the right shapes for drawing the anatomical features.

A Three-dimensional Sketch

A mannequin can really be considered a three-dimensional sketch, since its parts are a simplification of anatomical shapes. Drawing the mannequin by copying its parts faithfully requires placing each body part in correct relationship to the others.

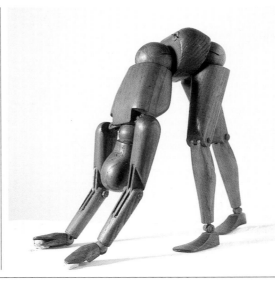

PROPORTIONS, MUSCLES, AND BONES

THE TORSO

The torso is made up of the thorax and the abdomen, and from an artistic viewpoint, it is the most important anatomical part. The fact that most fragments of classical statues are torsos has had a major influence on the symbolic importance attributed to this part of the body. The torso symbolizes the traits of strength, beauty, and esthetic perfection in representations of human anatomy.

Bones of the Torso

The framework of the torso is dominated by the large volume of the thoracic cage or thorax, which is defined by the ribs, the sternum, and the vertebrae (which will be examined in subsequent pages). The twenty-four ribs that form the thorax give it a characteristic barrel shape that is narrower and shorter in women than in men. In the rear, the thorax is formed by the vertebrae, which are joined to the ribs by joints that are capable of limited movement; this makes possible the flexions and rotations of the torso. The bones of the torso are completed by the shoulder joints (known as the scapular belt) formed by the union of the clavicle, the shoulder blade, and the humerus.

Articulation and Relief in the Thorax

The thorax has a set of articulations in the ends of the ribs that makes them movable to a limited extent and helps them accommodate bends and twists in the torso. So when you inhale sharply, for example, the lungs inflate and the arcs formed by the ribs rise slightly toward horizontal, and the shape of the ribs and the bottom of the thorax stand out. These points are similarly visible when the torso is inclined rearward, when the arms are raised, and when the abdomen is contracted.

Muscles of the Torso

The trunk is covered by broad muscles of varied shapes that are especially strong in the areas where they join the limbs. They are categorized as pectoral muscles and abdominal muscles. The pectoral muscles are the *pectoralis majoris*, which covers the chest and radiates outward from the upper part of the humerus and inserts into the clavicle, the sternum, and the ribs; the *pectoralis minoris*, which is hidden from view under the *pectoralis majoris* when seen from the front; and the *serratus*, which originates at the eight upper ribs and extends rearward to insert at the internal edge of the shoulder blade.

The most important abdominal muscles are the *rectus* (which produces the characteristic six-part relief in the abdomen) and the *oblique*, which continues downward toward the *serratus* and inserts

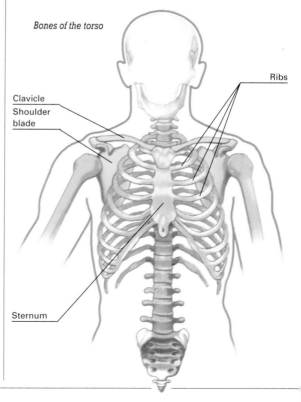

Bones of the torso

Ribs

Clavicle

Shoulder blade

Sternum

at the hip. Inside the torso the dorsal muscle can also be seen (see subsequent pages); it inserts into the upper portion of the humerus.

Relief in the Torso

For artists, drawings of anatomical relief in the torso should differentiate the thorax from the abdomen through a line of demarcation under the thoracic cage. This line is especially visible in athletic figures and in models from classical art. Other distinctive traits of the torso are the pectorals and the *serrati*, which are always very prominent in Greco-Roman statues. The lower edge of the torso also stands out noticeably because of a fold that borders the *serrati* and rises to the region of the hips.

| MORE ON THIS SUBJECT |

• Skeletal References, **p. 22**
• References to Muscles, **p. 24**

Muscles of the torso

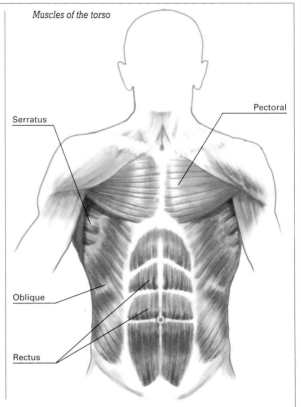

Serratus

Pectoral

Oblique

Rectus

The "Esthetic Armor"

This is the name that was applied to representations of the torso in the French Academy in the seventeenth and eighteenth centuries. Evidently, the identification with armor derives from the military uniform of the Roman legions, and also from the fact that the thorax and abdomen together have been the most significant emblem of classical esthetics in representations of human anatomy ever since the famous sculpture of the Laocoön group.

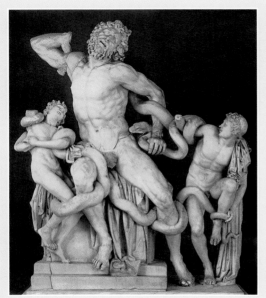

The torso in the famous Laocoön group is one of the most powerful and persistent symbols of anatomical representation.

LAYING OUT AND DRAWING THE TORSO

Even though the torso is much more limited in its autonomy of movement than the arms and the legs, in a certain way it influences nearly all the movements and positions of the body. With the help of an articulated mannequin, it is easier to understand the characteristic movement of the torso and the effects of this movement on the other parts of the body.

Three Sections

The parts of the mannequin make it possible to understand the configuration of the trunk in three sections: the torso, the waist, and the hips. Each of these sections is represented by a movable part. This grouping makes it easy for the illustrator to adjust the shape

Even with its rudimentary articulations, the mannequin reproduces the posture of Michelangelo's figure and serves as an aid in drawing the pose.

Graphic reconstruction that analyzes the muscular system operating beneath the skin in a figure by Michelangelo. Note the great tension in the pectorals, the undulation of the abdominals, and the appearance of the clavicle and the sternum in the shallow relief of the sinewy areas.

The preliminary sketch for the drawing must reinterpret the shapes of the articulated mannequin and adapt them to the sinuous nature of the large mass of the figure's torso.

of the trunk and understand its movements and figure out the resulting muscular actions and reactions. In the movement examined in these pages, based on a figure by Michelangelo, we can see how the tension in the arms is transmitted to the pectoral muscles, and how the position of the hips is reflected in the abdominal muscles. On the sides, the oblique muscle is deformed by the tension applied to the armpit, and a small section of the *latissimus dorsi* is visible. There is also a noteworthy effect—and one worth preserving in illustrations—of the internal organs beneath the abdominal muscles.

Graphic Construction

The layout derived from the parts of the mannequin is a graphic construction that makes both the proportions and the movements of the trunk more comprehensible. Just the same, this construction is only a tool to create an accurate anatomical representation. You have to imagine the three parts of the trunk translated into terms of muscles. Then the upper part would contain the pectoral muscles, the upper abdominals, and the *serrati*; the central part would be formed by the middle abdominals; and the lower part or the abdomen, by the lower abdominals.

The Female Figure

Laying out the female trunk is basically the same as with the male, but with some significant differences. One indispensable feature in framing the figure is that the hips of a female are broader. Since the parts of a mannequin are intended to serve for both masculine and feminine figures, the illustrator has to modify the size of the hips in relation to the rest. Similarly, the size of the torso has to be enlarged in illustrations of male figures. The breasts can be included from the beginning or added at the end.

In this example, the framing pieces or blocks also convey a sinuous, twisting movement. This case involves a female figure.

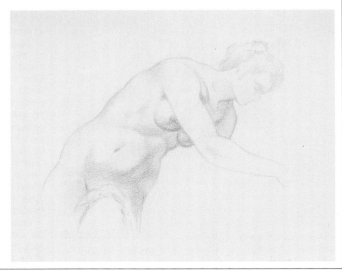

MORE ON THIS SUBJECT
• The Torso, **p. 32**

In the finished drawing, the shape of the abdomen and the breasts is evident, as well as the particular contour of the back, which marks the transition between the dorsal, pectoral, and abdominal muscles. Practice piece by Josep Torres.

THE BACK

The basic components of the back are the bones of the spinal column, which are connected to most of the bony areas in the body. The back is comprised of some very strong muscles that keep the body erect and provide adequate support. Most of these muscles are broad, flat ones, and they overlap one another to provide the characteristic shape that is visible in the back.

Bones of the Back

In the back the skeleton is composed of the same bones that can be seen in the frontal view: ribs, shoulder blades, and clavicles; of course, there is also the spinal column.

The vertebral column is the central axis of the trunk. It runs through it from top to bottom, from the base of the skull—centrally located behind the lower jaw—down to the sacral bone in the pelvis, which in its central part holds up the thorax. It is formed by

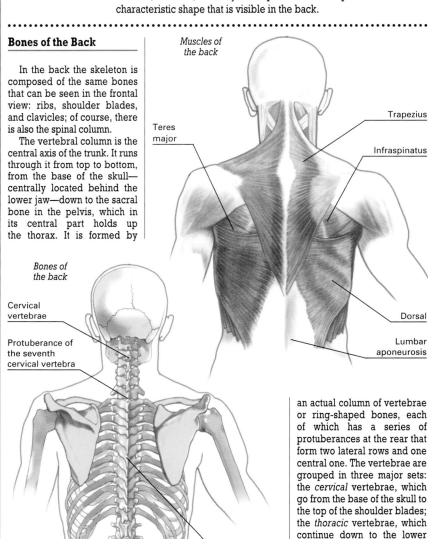

Muscles of the back

Teres major

Trapezius

Infraspinatus

Dorsal

Lumbar aponeurosis

Bones of the back

Cervical vertebrae

Protuberance of the seventh cervical vertebra

Thoracic vertebrae

Lumbar vertebrae

an actual column of vertebrae or ring-shaped bones, each of which has a series of protuberances at the rear that form two lateral rows and one central one. The vertebrae are grouped in three major sets: the *cervical* vertebrae, which go from the base of the skull to the top of the shoulder blades; the *thoracic* vertebrae, which continue down to the lower part of the thorax; and the *lumbar* vertebrae, which reach down to the bottom of the spinal column.

Visible parts that determine the external contour of the back include the outer edge of the clavicle (visible in the

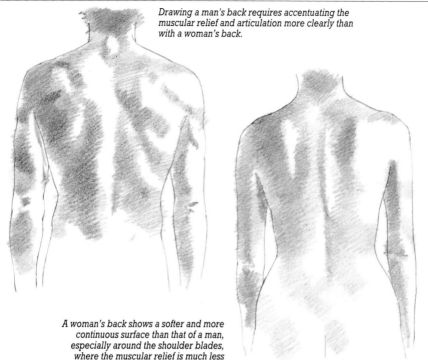

Drawing a man's back requires accentuating the muscular relief and articulation more clearly than with a woman's back.

A woman's back shows a softer and more continuous surface than that of a man, especially around the shoulder blades, where the muscular relief is much less pronounced than with men.

apex of the shoulders) and the protuberance of the seventh (and last) cervical vertebra, which is located between the shoulder blades.

Muscles of the Back

The upper part of the back is dominated by the *trapezius*, a smooth muscle that covers the upper part of the shoulders. It originates in the occipital bone in the skull and the cervical and thoracic vertebrae, and it inserts into the upper part of the clavicle and into the end of the shoulder blade.

The *infraspinatus* and *teres* muscles are located in a deeper level of the lower outside area of the *trapezius*; the dorsal muscle and the deltoids, on the outside of the shoulder, are superimposed on these. The dorsal muscle originates in the lower six dorsal vertebrae, in all the lumbar vertebrae, and in the outer rear portion of the iliac crest. The dorsal muscle goes around the rear and the side of the thorax, and as previously explained, it inserts into the upper part of the humerus. This wrapping around produces the characteristic profile that can be seen in the upper part of the hip.

The Lumbar Aponeurosis

An aponeurosis is a sinewy membrane or flat tendon into which various muscular fibers insert. The lumbar aponeurosis (technically, the *dorsolumbar fascia*) is the tendinous area that forms the relief typical of the lumbar region and produces the characteristic dimples on both sides of the lumbar vertebrae that are particularly visible in a woman's back.

The lumbar aponeurosis is the sinewy area in the lower part of the back.

PROPORTIONS, MUSCLES, AND BONES

LAYING OUT AND DRAWING THE BACK

Like the torso, the back has no mobility comparable to that of the arms and legs,
but it presents a very harmonious anatomical unity, especially in the case of women.
The torso is a complex surface where it is not easy to identify clearly every anatomical
feature; the spinal column is the major point of reference.

Laying Out the Back

The large muscle masses of the back are clustered around the spinal column: the trapezius, the dorsal muscle, and the gluteals. In addition, we have to remember that part of the anatomical relief in the back is due to the large tendinous lumbar area in which the deep muscles are hidden by the lumbar aponeurosis, which was mentioned earlier. All of this can be illustrated by a layout based on the shapes of the articulated mannequin.

The shapes for framing the back are the same ones that are used with the trunk, and their proportions need to be adjusted to suit either a masculine or a feminine figure.

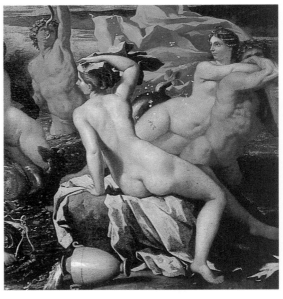

Nicolas Poussin. The Triumph of Neptune (detail).
Philadelphia Museum of Art. This feminine back is rather original in classical iconography.
It surely required a careful study of anatomy on the artist's part to achieve the harmony and delicate continuity of its shapes.

This illustration is the result of an anatomical analysis of the feminine figure by Poussin. The shape of the back, although attenuated in the painting, is determined by a rich series of undulations in the trapezius and the dorsal muscle. The lower part is resolved in the lumbar region, which has a sinewy quality, and the hips reveal the shape of the pelvis and the position of the gluteals.

The pose of the figure by Poussin is reproduced approximately with the help of the mannequin, which once again provides an important service to the illustrator by serving as a pattern for laying out and establishing the proportions of the finished figure.

Drawing Muscular Relief

Once the back has been laid out, it is important to have recourse to a model (a photo, a painting, or a living model) in order to provide the proper relief. Without a good model it is difficult to organize the layers of muscle that give shape to the shoulders, the back, and the lumbar region.

The Muscles that Wrap Around the Shoulder

In order to understand the muscular relief in the shoulder, you have to understand it as a wrapping of various layers that continue into the torso. Thus, the trapezius, which originates at the clavicle and in the arm pit, goes around the rear of the shoulders and inserts into the side of the spinal column. A similar situation occurs with the dorsal muscle, which hugs the sides and extends downward toward the lumbar region. These two muscles constitute the anatomical wrapping of the back.

This picture illustrates the concept of the "muscular wrapping" that may help in understanding the relief in the back. It is composed of broad, flat layers of muscle that wrap around the body.

It is best to choose a good picture, reproduce the pose of the figure using a mannequin, lay out the back of the figure based on the mannequin, and complete the illustration referring once again to the chosen image.

The mannequin presents only an approximation of the true pose, which consists of a progressive twist in the back, the waist, and the hips, so that each of these areas lies in a different plane.

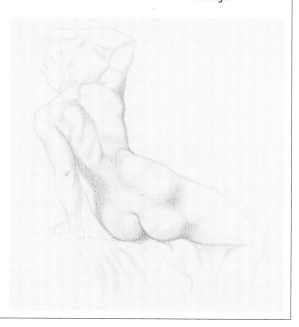

The layout of this pose is really the most difficult part; once you have done a satisfactory job of it, you have to be consistent in the articulation of the various parts, giving them the unity dictated by the shading of anatomical relief. Practice piece by Josep Torres.

THE HIPS

The hips connect movements in the trunk with those in the legs. Even though the hips involve a set of bones with scarcely any articulation of their own, they exert a tremendous influence on the external relief of the body. If you have a good knowledge of the bony and muscular configuration of the hips, you can create an accurate representation of the transition between the trunk and the legs.

Bones of the Hips

The structure of the hips is determined by the pelvis, which is composed of three bones that are solidly fused together: the *ilium*, the *ischium*, and the *pubis*. The ilium is the largest of the three, and it provides the characteristic shape of the pelvis; its upper edge forms the *iliac crest*, which is visible on the outside beneath the lateral protuberance of the dorsal muscle. The ischium is located farther down and appears as an extension of the ilium. The bone of the pubis forms a belt with the ischium, and its outside edge accommodates the joint with the femur. This bone is held in the pelvis by a hemispheric head that joins the main body of the bone through the *neck of the femur*, and it ends in a protuberance known as the *trochanter major*. This protuberance is visible in the external relief of the leg when it is bent rearward. The *sacral* bone is located to the rear of the pelvis; this is where the spine terminates.

Muscles of the Hips

Seen from the rear, the most salient muscles of the hip area are the *gluteus medius* and the *gluteus maximus*. Both originate at the iliac bone. The gluteus medius inserts into the top of the femur, and the gluteus maximus into an aponeurosis (the *fascia lata*) located on the sides of the buttocks. The gluteus maximus covers numerous internal muscles that insert into the pelvis or originate in it. The prominence of the gluteals completely obscures the relief of the hip bones. Seen from the front, the muscles of the trunk give way to those of the legs, and the ligaments of the loins provide the only continuity.

Frontal view of the bones of the hips

Rear view of the muscles of the hips

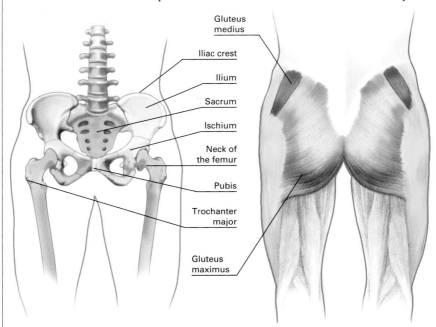

Gluteus medius

Iliac crest

Ilium

Sacrum

Ischium

Neck of the femur

Pubis

Trochanter major

Gluteus maximus

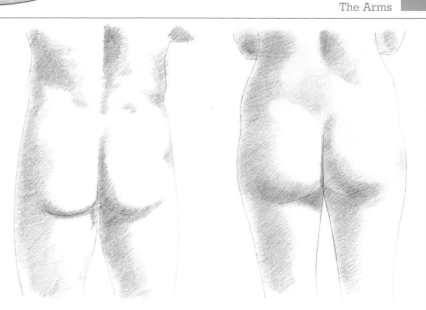

The hips of a female (right) are much larger and rounded than those of a male, and the bones are less visible.

The Ischial Position

The ischial position involving the hips consists of supporting the entire body on one leg and leaving the other one relaxed. The name of the position is due to the tipping of the ischial bone, which is located in the center of the pelvis and which inclines to one side or the other depending on the movement of the hips. This position, which carries the weight of the body on one leg, is the one most commonly drawn of standing figures.

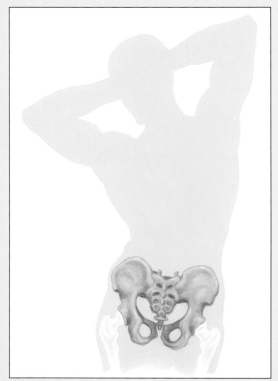

In the ischial position, the relief of the pelvis is clearly visible beneath the skin.

THE ARMS

The anatomy of the arms is relatively simple with respect to the bones, but the set of muscles is fairly complex, especially in the forearm. This complexity is explained by the rotating movement of the forearm, involving the superposition of the radius and the ulna. This is what makes it possible to move the hand with complete mobility.

Bones of the Arms

The bones of the arms include the *humerus* (long arm bone), the *ulna*, and the *radius* (in the forearm), plus the bones of the hand. The humerus is jointed with the clavicle and the shoulder blade. These three bones always move together when the shoulder is raised or lowered, when the arm is extended or raised, and so forth. The radius is located on the same side as the thumb, and the ulna on the side of the little finger. The only visible part of the exterior relief formed by

Pronation and Supination

Pronation and supination are characteristic movements of the forearm. Pronation causes the hand to rotate so that the back faces upward. Supination causes the palm to remain in the position typically used to hold some object.

the arm bones is the characteristic protuberance of the elbow,

which corresponds to the upper extremity of the ulna, and to a lesser degree, the upper end of the radius located next to it. In slender people, the lower extremities of these two bones are also visible near the wrist.

Articulation of the Forearm

The system of articulation of the forearm, which makes it possible to rotate the hand, is based on the relative positions of the ulna and the radius.

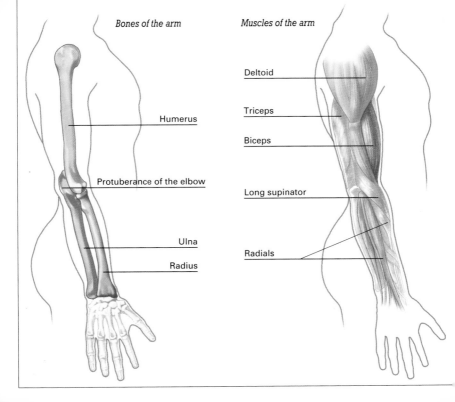

Bones of the arm

Humerus

Protuberance of the elbow

Ulna

Radius

Muscles of the arm

Deltoid

Triceps

Biceps

Long supinator

Radials

Drawings of men's arms have to show the relief of the muscular forms much more clearly than those of women's arms.

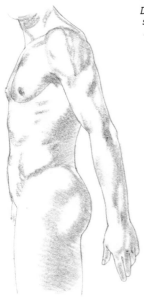

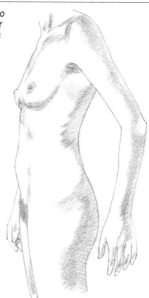

When you hold your arm with the palm of the hand facing forward, these bones are parallel to one another; but if you face the palm of your hand toward your body, and especially, when you turn it downward, the radius crosses over the ulna and makes the rotation possible.

Supination movement

Muscles of the Arms

The most important muscles of the arms are the deltoid, which covers the shoulder like a cap; the biceps, which runs along the front of the humerus; and the triceps, which runs along the rear of the upper arm. The front of the forearm is comprised of many long muscles that are referred to as *pronators* and *supinators*, which facilitate hand movements, and of the *palmar muscles*. The radial muscles are visible on the outer edge of the forearm; they make it possible to bend the hand toward the rear.

Pronation movement

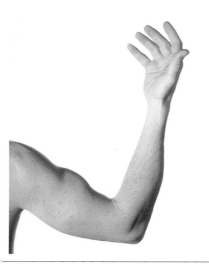

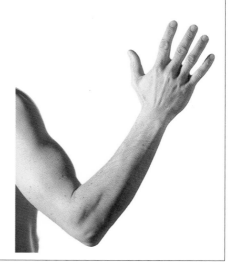

PROPORTIONS, MUSCLES, AND BONES

DRAWING THE ARMS

Great artists who depict nudes emphasize the muscular relief in the arms as a means to express strength and dynamism. This relief is usually dominated by the great size of the deltoids and the biceps, which form a succession of nearly spherical masses of great visual interest. The mannequin is still our best ally in doing credible illustrations involving the arms.

Parts of the Mannequin's Arms

The arms of the mannequin are composed of six pieces: three joints that correspond to the shoulder, the elbow, and the wrist, and three sections that represent the forearm, the upper arm, and the hand. The joints are spheres or balls that are very easy to draw; the other parts are cylinders that are likewise free of difficulties for the illustrator. It is essential that the preliminary sketch contain the parts in the right proportions with respect to length and thickness; otherwise, the end result will appear distorted.

Drawing the Muscles

The shapes of the muscles in the upper arms are essentially dictated by the deltoid and the biceps. In the forearm, the shapes of the muscles are less obvious, but it is interesting to highlight the striated relief produced by the set of muscles involving the common extensor of the fingers and the radial and

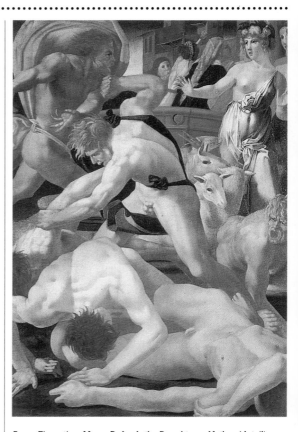

Rosso Fiorentino. Moses Defends the Daughters of Jethro (detail). Gallery of the Uffizi, Florence.

Muscles as Cords

The arm muscles, especially the ones in the forearm, recall the shape of the strands in a rope, coiling over one another to form a solid body. This is especially noticeable in the anterior *brachioradialis* muscle, which originates in the lower part of the deltoid and descends through the outside of the upper arms and inserts among the muscles of the forearm.

supinating muscles. The illustrations on these pages are a study of some arm movements that hold particular visual interest.

It is important to draw the shapes of the muscles without defining their limits. There should also be a smooth transition from one muscle to the next. To achieve this, it is a

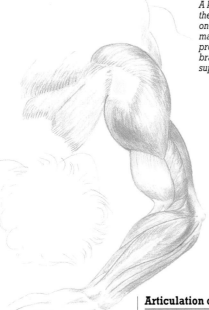

A knowledge of anatomy makes it possible to recognize the muscles that come into play in poses such as the one in the painting. The arms are dominated by the mass of the deltoids and the biceps, and the triceps also protrude a bit. One can also see the long, narrow brachial muscle, and in the forearm, the radial, the supinator, and the common extensor of the fingers.

Approximate reconstruction of the figure that appears in the detail of the painting reproduced here, using the articulated mannequin.

Articulation of the Elbow

The articulation of the elbow can present some problems in illustrating, since its irregular shape changes quite a bit according to whether or not the arm is extended. In general, we have to consider that the elbow is an area where the upper arm and the forearm constrict, and that shows relief in its rear as well as on the outside. Drawings of this relief should be completed only after the preliminary sketch is perfectly proportioned.

good idea to refer to good photographic models to get the relief of every muscle right and verify the overall layout of the arm.

The mannequin serves as a means of layout and composition of the basic anatomical parts and their articulation.

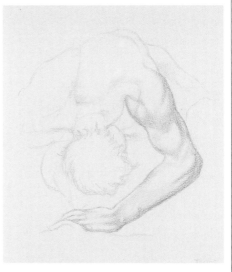

Once the articulation of the arm is laid out in the proper proportions, the knowledge of anatomy can be put to use in completing the drawing.

THE LEGS

The leg bones originate at the union between the thighs and the trunk, in other words, where the femur attaches to the pelvis. Then there are the patella in the knee joint, and the tibia and the fibula in the lower leg. The muscle mass of the thigh is dominated by the *rectus* and the *vastus lateralis* and *vastus medialis* muscles. The relief in the lower leg is determined mainly by the characteristic profile of the calf muscles.

· ·

Bones of the Legs

The leg is comprised of four bones: the femur, the knee cap, the tibia, and the fibula. The femur or thigh bone is the longest and the most robust of the bones in the skeleton. Seen from the front, the lower part of the femur contains the kneecap, which gives shape to the knee. The tibia and the fibula are arranged much as the bones of the forearm are: the tibia is larger than the fibula. In the foot joint (the ankle), the outer face of the tibia ends in the *malleolus externus*, situated lower and farther to the rear than the *malleolus internus*, which is a protuberance in the bottom of the fibula.

Muscles of the Legs

Seen from the front, the most important muscles of the thigh are the *vastus externus* and the *vastus internus*, located on both sides of the *rectus* muscle (to the outside and inside of the leg, respectively), and the *sartorius*, the long, slender muscle that crosses the thigh from the

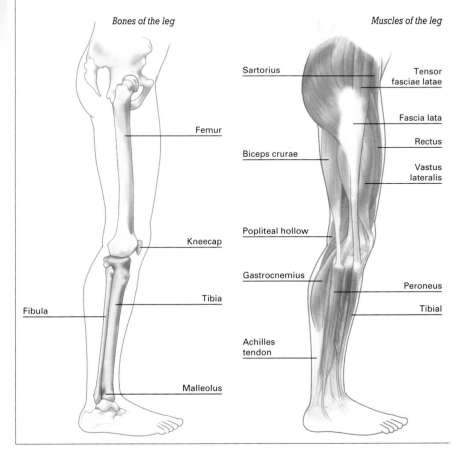

Bones of the leg

- Femur
- Kneecap
- Tibia
- Fibula
- Malleolus

Muscles of the leg

- Sartorius
- Tensor fasciae latae
- Fascia lata
- Rectus
- Vastus lateralis
- Biceps crurae
- Popliteal hollow
- Gastrocnemius
- Peroneus
- Tibial
- Achilles tendon

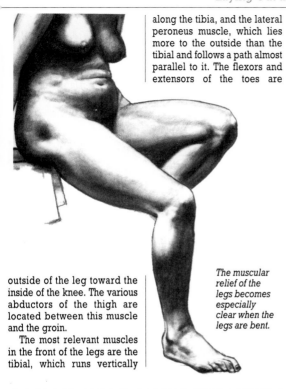

along the tibia, and the lateral peroneus muscle, which lies more to the outside than the tibial and follows a path almost parallel to it. The flexors and extensors of the toes are

outside of the leg toward the inside of the knee. The various abductors of the thigh are located between this muscle and the groin.

The most relevant muscles in the front of the legs are the tibial, which runs vertically

The muscular relief of the legs becomes especially clear when the legs are bent.

located between these two muscles. In a side view, the gluteal muscles and the large tensor of the *fascia lata* stand out; the latter becomes evident when the leg is bent completely at the knee. In a rear view, there are two nearly parallel muscles that deserve mention: the *biceps crurae* and the *semitendinosus*, and in the calf, the impressive shape of the *gastrocnemius* connected to the heel by the Achilles tendon.

Adduction and Abduction

Adduction is the movement by which a limb approaches the body's plane of symmetry. An example of adduction occurs when a soldier moves from at ease to attention. Abduction, on the other hand, involves movement away from the medial plane of the body.

The Popliteal Hollow and the Shape of the Femur

The popliteal hollow is the cavity that can be seen in the rear of the leg at the level of the knee; it becomes especially evident when the leg is bent with the muscles tensed, when the tendons of the *biceps crurae* and the *semitendinosus* create the characteristic central hollow.

Another anatomical feature relevant to drawing the legs involves the relief of the *trochanter major* or the prominence in the articulation of the femur, which becomes visible especially when the leg is moved to the rear.

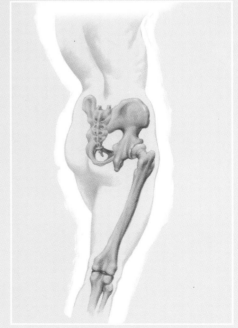

The articulation between the pelvis and the leg becomes clear in the lower left part of the hip when the leg is moved rearward.

LAYING OUT AND DRAWING THE LEGS

The legs can be laid out using the characteristic shapes of the articulated mannequin. The process continues by adding the relevant anatomical features to the sketch little by little in accordance with proportions previously established. As in earlier examples, the best results are obtained by using the mannequin and a photographed model or a painting.

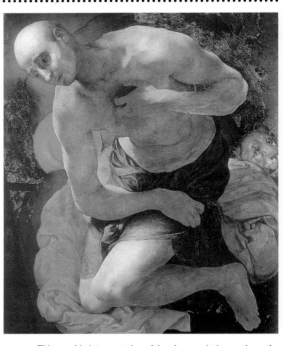

Jacopo Pantorno. Saint Hieronymus. *Lower Saxony National Museum, Municipal Gallery (Hanover, Germany). A work by a virtuoso in anatomy, this painting shows a refined synthesis of the leg muscles.*

The Shape of the Legs

The shape of the legs, especially in the thigh, changes considerably when the legs are bent. The rectus muscle, which runs along the front of the thigh from the groin to the knee, broadens, the tensor of the *fascia lata* extends, and the articulation of the knee becomes very evident. Similarly, the calf muscles press against the thigh and produce the characteristic fold in the rear of the knee joint.

This graphic interpretation of the above painting analyzes the anatomical arrangement of the subject's leg. It is worthwhile to point out that the relief in the knee is due in part to the ligaments, and at the sides, to the appearance of the femur.

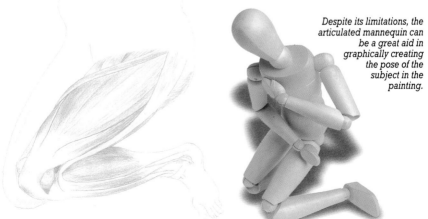

Despite its limitations, the articulated mannequin can be a great aid in graphically creating the pose of the subject in the painting.

The simplicity of the schematic shapes makes it possible to check the correct position of the leg before starting to draw the details.

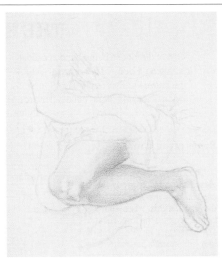

The shape of the legs is completed by shading the areas that require clear definition in the muscular relief.

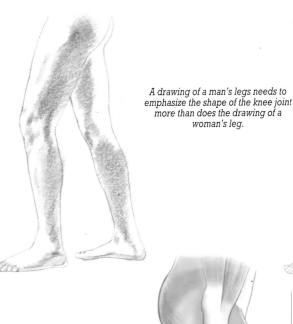

A drawing of a man's legs needs to emphasize the shape of the knee joint more than does the drawing of a woman's leg.

The most notable swellings in the leg muscles during energetic movements are in the thigh (the rectus and semitendinous muscles) and in the calf muscles.

As with the arms, an accurate rendition of the legs requires a competent preliminary sketch and correct proportions in the individual parts. Just the same, the legs carry the weight of the body, and this fact must be borne in mind, since the sensation of balance is of the utmost importance. In most of the leg drawings on this page, a preliminary layout was used based on the representative parts of the articulated mannequin.

PROPORTIONS, MUSCLES, AND BONES

THE HANDS

Most of the bones in the hand are close to the surface, and that must be considered in drawing a bony hand, or even a slender one. In addition, the many articulations in the fingers are more clearly understood by interpreting their relative positions as points located along concentric arcs. With regard to the muscles, their relief is especially visible in the palm.

Bones of the Hands

The bones of the hand are classified in three groups: the *carpals*, the *metacarpals*, and the *phalanges*. The carpal bones prolong the forearm and are arranged in two rows of four bones each. There are five metacarpal bones; they cross the center of the hand and connect the carpal bones with the phalanges. They increase in size from the little finger to the index, and the metacarpal of the thumb is the stoutest and shortest. The heads of the metacarpals form the relief of the knuckles. Each finger consists of three phalanges, except the thumb, which has just two. The phalanges are progressively shorter, so that the second phalanx is the equivalent of two-thirds of the

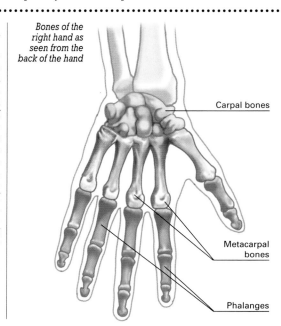

Bones of the right hand as seen from the back of the hand

Carpal bones

Metacarpal bones

Phalanges

Abductor of the little finger

Opponent of the little finger

Palmar interosseal muscles

Opponent of the thumb

Short abductor of the thumb

Flexor of the thumb

Abductor of the thumb

Palm muscles of the left hand

first, and the third is two-thirds of the second.

Muscles of the Hands

The muscle system of the hand is a complex framework of small muscles and tendons that make possible the many movements of the fingers. For our purposes, it will suffice to point out the muscles that give the hand its characteristic relief: the abductor and the flexor of the thumb, which form the broad, fleshy protuberance at the base of the thumb, and the abductor and the opponent of the little finger, which provide shape to the edge of the hand.

MORE ON THIS SUBJECT

• Drawing the Hands, **p. 52**

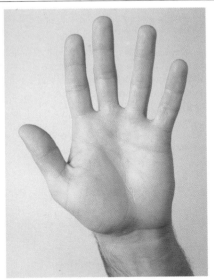

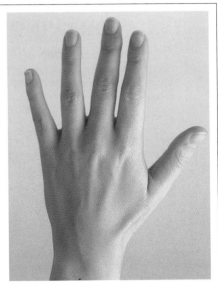

*The anatomy of the hand muscles is much more evident in the palm
and the anterior face of the fingers than in the back of the hand.*

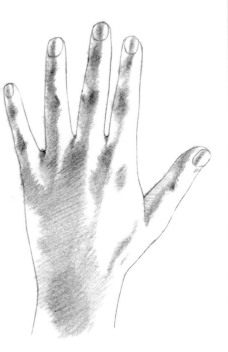

Drawing the Hand

The bones of the fingers are merely extensions of the metacarpals; as a result, in drawing the hand, the location of the knuckles always has to be adjusted to the knuckles of the fingers; in other words, they have to be aligned. In addition, the articulations of the fingers always fall on a series of parallel curves.

*All the knuckles of the hand are aligned
on concentric arcs.*

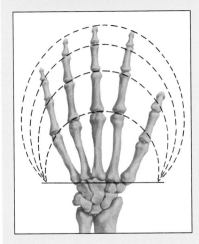

*Tendons run through the back of the hand and give
the surface a characteristic relief when the fingers
are extended.*

DRAWING THE HANDS

The many articulations in the fingers, their difference in size and proportion, and the great mobility of the hands often create difficulties for inexperienced illustrators. Drawings of hands reveal a lot about an artist's skill and immediately betray any shortcomings in the work. The pictures on these pages show how to drawy folded hands.

Laying Out the Drawing

Layout is always an indispensable step in every anatomical drawing, and it is especially crucial in drawing the hands. In reality, the layout is the most difficult part in drawing the hands, since it includes numerous parts that comprise a whole that scarcely needs the addition of shading and tones once the components are laid out and proportioned correctly. The layout of folded hands begins with schematic shapes in which there is no distinction among fingers, but rather only among planes; that is, among surfaces with different orientations. It makes sense for these surfaces to correspond to the phalanges and for their arrangement to represent the articulations of the knuckles. The profiles of the fingers are arranged on this sketch.

Developing the Subject

The preliminary sketch is done in pencil to make it easier to adjust all the parts; next, an artist's pen and ink are used to give the drawing a little more detail. The articulations in the phalanges and the knuckles can simply be indicated using a few strokes of the pen. You have to keep in mind that the location of these articulations depends on the length of each phalanx, which follows a decreasing order: the second phalanx is equivalent to two-thirds of the first, and the third to one-third of the second.

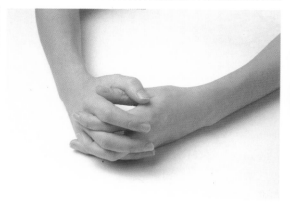

Seen from this angle, the fingers appear in a vertically descending plane; the thumb, the index, and the middle finger of the subject's right hand are the only ones that are completely visible. Only the last phalanges of the other fingers can be seen.

When it is time to add shading, there is no point in doing too much, or the fingers might blend together. For the moment it is better to limit shading to the back of the hands.

Pen and ink strokes cannot be corrected; therefore, it is important to begin a drawing in pencil, using simple, precise lines that accurately represent the interlacing of the fingers.

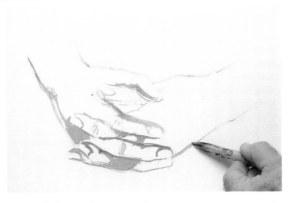

The broad stroke of a cane is used both for going over the outlines and for filling in broad areas of shading. These strokes and the initial shading are done with orange ink to avoid cluttering the drawing with very dark areas right from the beginning.

A little more shading has been done in light strokes using India ink diluted with water. This produces areas of transparent gray in a medium tonality that highlights shapes and anatomical relief.

Streamlining and Finishing

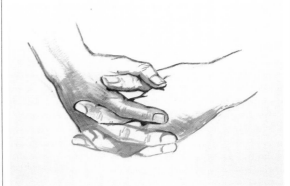

After the shading is done, the outlines of the fingers may not be entirely clear. To restore their shape it may be necessary to go over their outlines, but without exaggerating them. All the fingers must be clearly visible and be correctly proportioned. There should be no confusion in the whole, and the position of each finger should be seen clearly. This drawing was done in pen. As a result, the various shadings involving light and shadow were done using fine crosshatching, being very careful not to create any confusion between the shading strokes and the ones that define the outline of the fingers.

MORE ON THIS SUBJECT
• The Hands, **p. 50**

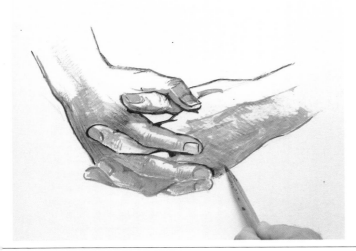

Finally, the cane is used on the shaded areas that need more attention. The pen strokes form a layer of soft and nearly transparent tonality. Work by Vicenç Ballestar.

THE FEET

The bones of the feet are distributed almost the same way as the bones of the hands, and they correspond in shape and location. For illustrators, the most significant features of the appearance of the feet are the arched form and the prominence of the heel produced by the heel bone. The foot shows its muscular structure only on the sole.

Bones of the Feet

As with the hands, the bones of the feet are divided into three categories designated as *tarsals*, *metatarsals*, and *phalanges*. The tarsals are composed of seven bones that are quite a bit larger than the carpal bones of the hand, since they have to support the weight of the entire body. Among them it is useful to distinguish the heel bone; this is the largest bone, and it provides shape to the heel as it rests on the ground. The metatarsals are also more robust than the bones of the metacarpus, especially the one that corresponds to the middle finger. The toes have the same number of phalanges as the fingers, but with the exception of the big toe, they are shorter.

Foot bones comprise the bones of the tarsus and metatarsus, as well as the phalanges. Highlighted in green among the tarsus bones is the calcaneus, which plays a significant role in the shape of the foot.

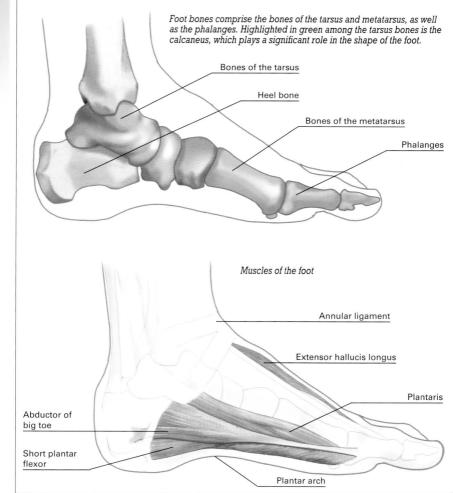

Bones of the tarsus

Heel bone

Bones of the metatarsus

Phalanges

Muscles of the foot

Annular ligament

Extensor hallucis longus

Plantaris

Abductor of big toe

Short plantar flexor

Plantar arch

Position of the Malleoli

In the ankle joint, the inner and outer malleoli are at different heights relative to the foot: the inner are a bit higher than the outer. This difference is visible only when the foot is seen from a completely frontal viewpoint, but it should always be borne in mind, even when drawing the side view of a foot, in order to avoid creating distortion.

The outer and inner malleoli are located at different heights: the inner ones are higher than the outer.

Muscles of the Feet

As with the hands, there are many muscles in the feet for moving the digits, but they are mostly insignificant in the overall external relief of the foot. Just the same, we need to mention that the shape of the foot is strongly characterized by the hollow of the sole or the plantar arch, which functions like a spring and absorbs stresses due to the weight of the body and provides elasticity to a person's movements. This arch, which is visible on the inside of the foot, owes its shape to the strong tendons that cross the sole of the foot.

MORE ON THIS SUBJECT

- The Legs, **p. 46**
- Laying Out and Drawing the Legs, **p. 48**
- Drawing the Feet, **p. 56**

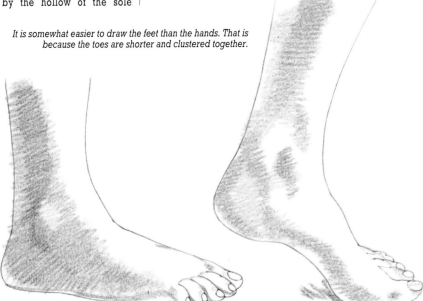

It is somewhat easier to draw the feet than the hands. That is because the toes are shorter and clustered together.

DRAWING THE FEET

As with the hands, drawing the feet can present some problems for the artist. Generally the problem involves the need to represent the weight of the body on the feet; in other words, to create the impression that the subject really is resting on the soles of the feet in proper balance. The pictures on these pages show how to do a drawing in which both feet rest on the floor over their entire length.

Feet Planted on the Ground

In addition to the necessary anatomical considerations involving the feet, illustrators always need to keep in mind that the shape of the feet is due also to the fact that they carry the entire weight of the body. A foot on the ground and a foot raised are not exactly the same; in the former case, the arch is much more visible than in the latter. Also, the toes are a little more spread apart in a foot that is planted on the floor than in one that does not bear the weight of the body. In the exercise presented in these pages, two feet planted on the ground are illustrated. They are arranged in a common position: while one of them carries the greater part of the weight, the other is more relaxed and pointed approximately perpendicularly toward the front, revealing the area of the heel and the Achilles tendon.

Colored Drawings

This exercise is done using colored chalk on gray colored drawing paper so that the shades of white will stand out. The process begins with a charcoal drawing that correctly locates the two feet. The most important thing in this preliminary drawing is not only the anatomical features, but also keeping both feet on the same plane so that one does not appear higher than the other or inclined differently. The right foot in the drawing clearly establishes the lay of the ground; the left foot must be drawn to confirm that inclination.

Shading

The schematic shape of the feet can be conceived as a cylinder that is flattened at the end, in the area of the toes. Keeping this shape in mind, it is possible to model it and

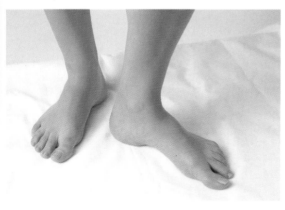

Here is the photo that is the basis for an exercise in drawing the feet.

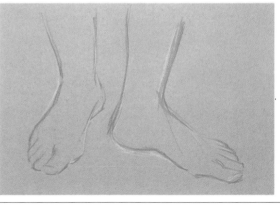

The preliminary sketch consists simply of drawing the outline of the feet, first with ochre chalk, and then with red to accentuate the profile.

shade it by adding the protuberance of the heel in the rear and the divisions that correspond to the toes in the front. It is necessary to be attentive to the correct location of the malleoli or anklebones. Even though both anklebones of a single foot are not visible at the same time in this drawing, it is crucial to realize that the outer anklebone is lower than the inner one so that when the foot is viewed from the front, the protuberances are not symmetrical. In the shading process the transitions and relief should be softened to represent correctly the curves and undulations of the outlines.

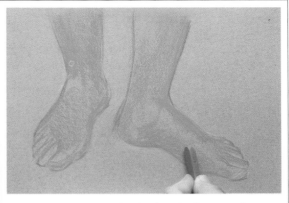

The first general shading is done by obscuring the contour that represents the sole and indicating the relief produced by the protuberances of the anklebones.

Shadows and Colors

The skin is colored at the same time the shapes are shaded. Black is used for the darkest shadows, red for intermediate tones, and ochre and white for the parts that reflect light. Worked in this way, the shape fills out at the same time the drawing is colored in. If the preliminary sketch was done properly, there should be no further problems.

The most prominent anatomical features are highlighted by applying a few strokes of white chalk and blending them into the tones of the paper and the red used in shading.

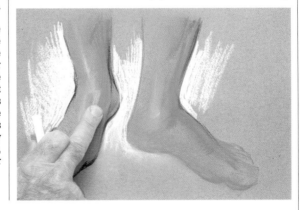

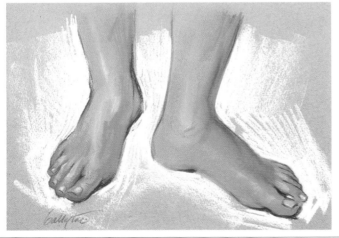

The finished product is anatomically correct and succeeds in communicating the solid contact of the feet on the ground: both feet appear on the same plane even though they are oriented in different directions. Work by Vicenç Ballestar.

THE SPINAL COLUMN

The spinal column is the central axis of the trunk. It runs from top to bottom, from the base of the skull to the sacral bone of the pelvis, and in its ventral part it sustains the thorax. It is formed by an actual column of vertebrae or ring-shaped bones whose articulations facilitate a considerable range of movement.

Vertebrae

The vertebrae of the spine are held apart from one another by cartilaginous discs that allow for rotation, flexion, and lateral inclination. Seen from the front, the spinal column appears straight, but a side view reveals a more sinuous shape. The first curvature toward the interior occurs at the level of the neck, and it turns toward the exterior of the body in the upper region of the back near the thorax. Following the vertebrae downward, the curvature again turns inward until it reaches its greatest intrusion in the lumbar region, at which point it angles outward one more time until it reaches the sacrum. These curves absorb the shocks produced by movements in the lower limbs, provide elasticity to the step, and produce the central groove in the back—an essential reference for all illustrators.

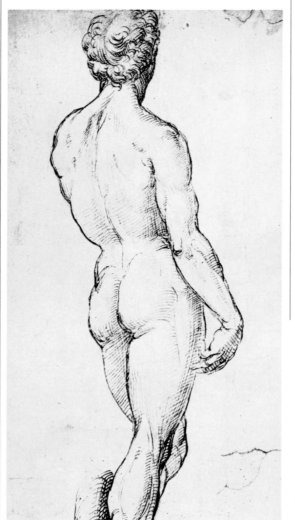

MORE ON THIS SUBJECT

- Skeletal References, **p. 22**
- The Back, **p. 36**
- Laying Out and Drawing the Back, **p. 38**

Raphael. Study of a Nude. Windsor Castle. The furrow of the spinal column is a linear reference that gives a sense of shape and movement to the back when it is drawn correctly.

Movements of the Spinal Column

The spinal column can turn on its own axis, twist, bend to the front, to the rear, to both sides, and so forth. These movements are combined perfectly with the positions of the body and the positions of the head, thorax, and pelvis. For artists, it is crucial to keep these movements in mind when drawing the back of a figure, since every movement in the spinal column has an effect on the external relief of the body. The furrow of the spinal column is also a very useful reference in laying out the drawing of a person seen from behind. Tracing this single line provides a good approximation of the subject's pose and movement.

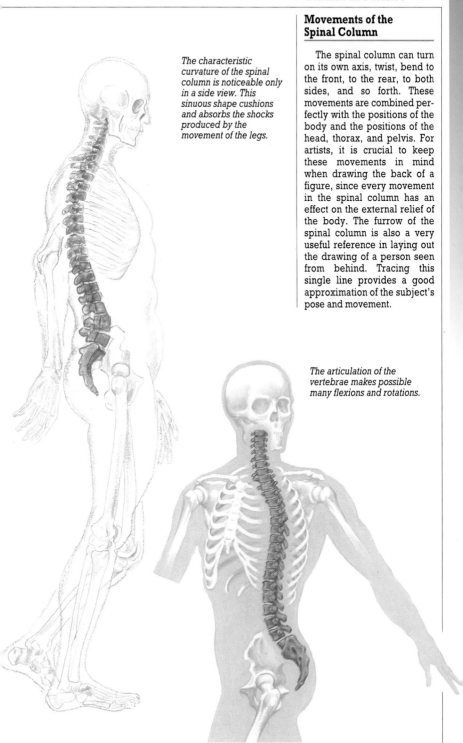

The characteristic curvature of the spinal column is noticeable only in a side view. This sinuous shape cushions and absorbs the shocks produced by the movement of the legs.

The articulation of the vertebrae makes possible many flexions and rotations.

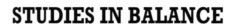

TECHNIQUE AND PRACTICE

STUDIES IN BALANCE

There are other drawing aids besides the articulated mannequin that can be of use to artists. Some of them are much simpler, and they make it easier to understand and reproduce movement and balance in the subject. They also maintain an immediate connection to anatomy.

The Importance of Balance

One major difference between anatomy for art and scientific anatomy is that the former is a means to achieving an adequate graphic or pictorial representation of the human body. As a result, any anatomical study would be incomplete if it did not address the issue of the figure's movement and its implications. The main implication is balance, an essential factor when it comes to giving cohesiveness to the drawing of a subject. Perfectly correct anatomical details do not amount to anything if the person represented does not appear to be standing upright.

The Line of Gravity

One rational way to check balance in a nude's pose involves locating the center of gravity, which is centered at the level of the last thoracic vertebra. As a point of reference it is useful to locate it in the navel in a frontal view, or in the upper part of the furrow of the spinal column in a posterior view. In order to check the stability of the figure, you can imagine this center of gravity and draw a vertical line that descends from there. If that vertical cuts the plane on which

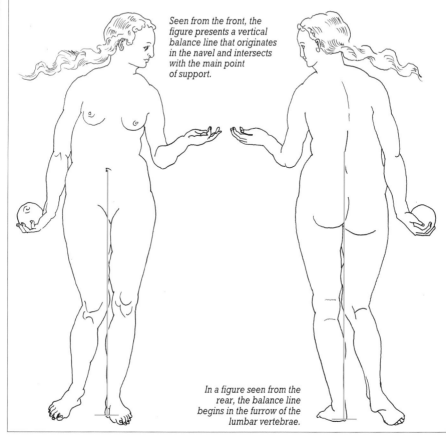

Seen from the front, the figure presents a vertical balance line that originates in the navel and intersects with the main point of support.

In a figure seen from the rear, the balance line begins in the furrow of the lumbar vertebrae.

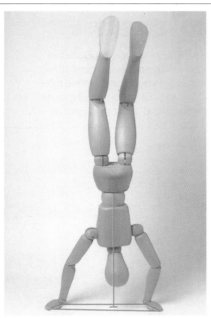

The equilibrium line always has to fall within the support surface.

Intuitive Calculation

With accumulated experience in drawing nudes, an artist develops the ability to sense a possible imbalance in a figure starting with the first stroke, and correct it as things progress without having to resort to verification. It should be noted that sometimes figures appear to be off balance even though a check of the center of gravity and the equilibrium line indicates the opposite. In such exceptional cases, the visual effect is the deciding factor. The drawing will have to be touched up until it appears to be in complete balance.

one of the feet is resting, then the figure is in proper balance. Otherwise, the representation may be unbalanced and the figure will not look like it is supporting itself. In the case of figures that are running or jumping, this check does not work, since the center of balance and the equilibrium line have been displaced and it is fruitless to try to locate them.

It is not even necessary to draw the center of balance and the equilibrium line; to run the check, you merely have to locate the point and place a ruler (or even a pencil) over it in a vertical position.

MORE ON THIS SUBJECT

• Studies in Movement, **p. 62**
• Laying Out the Pose, **p. 64**

The Support Surface

In most cases, the line of gravity does not intersect the plane on which one foot is located, but rather falls between both feet. That support surface is also a plane of equilibrium. To verify that, you merely have to join the vertices of an imaginary polygon defined by the figure's limbs

that rest on the ground. If the line of gravity cuts the surface of this polygon, then it can be safely concluded that the balance is credible. The supports of the figure can be the feet, the knees, the thighs, the forearms, or even just the hands. The crucial thing is that the line of gravity remain inside the plane defined by the supports.

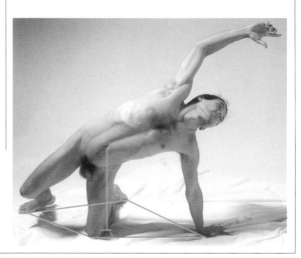

In this picture it can be seen that the equilibrium line falls within the support surface.

STUDIES IN MOVEMENT

It is possible to synthesize the movement of a figure through the location of some basic horizontal and vertical axes. The horizontal axes are those of the shoulders, the waist, and the hips. The vertical axes are the ones that join those parts to one another, plus the ones in the limbs and their corresponding joints. The system formed by these axes constitutes a virtual layout for movement.

Axes of Movement

From the viewpoint of drawing and artistic painting, the study of anatomy is inseparably linked to a study of movement in the human figure; this study sooner or later leads to a repertore of especially harmonious poses that serve as artistic reference points because of their naturalness and fluidity. The most famous of these movements originated in ancient Greece and was represented for the first time in the statue *Doryphoros* by the sculptor Polyclitus. This figure is striding forward in such as way that the shoulders are inclined in a direction opposite to the hips. The naturalness and dynamic fluidity of this contrast reappear constantly throughout art history to the point of becoming a type of model for a figure in repose. This movement is known by the Italian term *contraposto*, since it is based on the counterpoise of the two basic horizontal axes of all movement: those of the shoulders and the hips.

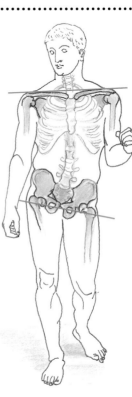

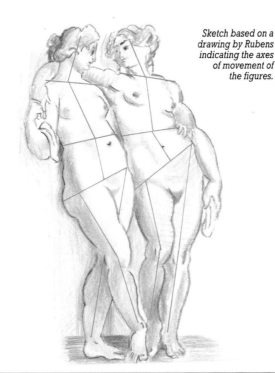

Sketch based on a drawing by Rubens indicating the axes of movement of the figures.

Anatomical sketch based on the Greek statue Doryphoros, *which shows the typical swinging motion of the hips.*

Contraposto

The Greek idea of presenting figures in *contraposto* enjoyed undeniable success in Western art. This position makes it possible to represent subjects in repose without imparting any rigidity to the anatomy, suggesting natural movement in the human

figure. There are many variations on this theme, from figures in which the counterpoise between the shoulders and hips is very slight, to attitudes where the arms and legs emphasize with their movement the contrasting angles between the shoulders and the hips. Mastery of *contraposto* also presumes complete control of such basic movements as walking and running.

Three Horizontal Axes

There is a third basic axis of movement that has to be added to the other two: the axis of the waist. This axis enjoys a certain autonomy of movement that is characterized by an intermediate position between the inclination of the shoulders and the hips. The waist is the area of articulation between the thorax and the abdomen, between the axis of the shoulders and that of the hips, owing to the considerable suppleness of the spinal column. These three axes (shoulders, waist, and hips) facilitate an elementary construction of any pose by merely establishing the respective fundamental inclinations.

Vertical Axes

The vertical axes of movement involve the trunk (from the base of the neck to the pubis), the abdomen (from the axis of the waist to the axis of the hips), the head, and the legs and arms (with the elbow and knee joints). Each of these axes is linked to the horizontal lines of movement, and their inclination is fundamentally dependent on them. This set of vertical and horizontal axes results in a sort of basic linear skeleton that is of great help to the artist in establishing the movement involved in any pose right from the beginning.

MORE ON THIS SUBJECT

- Studies in Balance, **p. 60**
- Laying Out the Pose, **p. 64**
- Sketches of Movement, **p. 66**

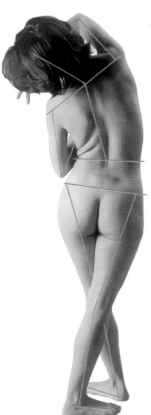

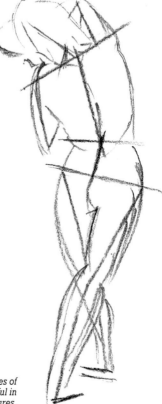

Sketch of the vertical and horizontal axes of movement in a pose.

A sketch of the axes of movement is very useful in drawing figures.

LAYING OUT THE POSE

Marking the axes of movement of a figure is equivalent to drawing a basic sketch of the pose. As a result, this skeleton of basic lines is a valid approximation of the entire figure. In combination with the outline shapes provided by the articulated mannequin, this procedure is the most useful one for creating an accurate anatomical representation.

Axes of Movement and Proportion

The figure's axes of movement make it possible to resolve the articulation of the pose based on the direction of the limbs. In the correct proportions, these axes can give rise to the entire illustration of the figure. In progressing from the drawing of these axes to the final result it makes sense to use the mannequin to create

This traditional pose in anatomy drawing serves as an example of the layout.

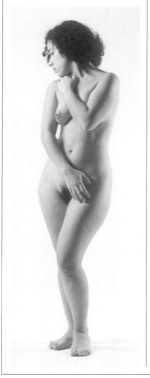

Geometrical Drawing

Cubist painters produced innovations in painting and drawing. Cubist drawing is characterized by its strictly geometric discipline, which often makes us think of a layout sketch developed just a little beyond the schematic state. Anatomy plays a secondary role in this type of work, but in most cases the proportions and the basic configuration of the human body are respected.

an accurate approximation of the anatomical relief. The axes of movement have to be proportioned correctly, but this is possible only after drawing some of the layout shapes that allow comparisons among them.

Layout Models

The linear sketch of the axes of movement must be balanced. If it is accurate, it is possible to draw the line of gravity to check the stability of the pose, even though

in most cases any potential imbalances will be readily evident. Only when the sketch is properly balanced can you continue drawing. The drawings illustrated on these pages were done based on the axes of movement in each pose. The sketch of the axes immediately suggests the layout models, and between these and the final illustration all that is needed is an adjustment to the representative outlines of the anatomical relief.

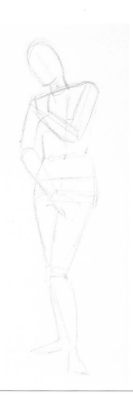

The slight counterpoise of the shoulders and the hips, with the weight on the right foot, is the basic element of balance in this pose.

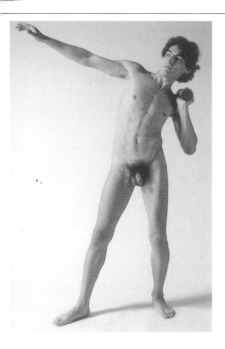

In this pose, the trunk follows a direction different from that of the hips, and the weight of the body falls on the subject's left foot; the extended arm serves as a counterbalance to the weight.

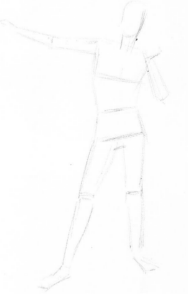

The sketch represents the movement in the pose through layout blocks.

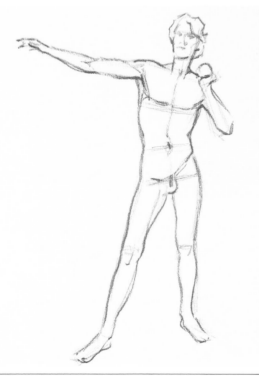

Straight Lines and Curves

Axes of movement are, logically, straight lines. Just the same, in constructing a modular sketch of a figure, it is a good idea to introduce a few curves to give a more organic sense to the layout and suggest reality of configuration in the limbs of the body. This will give a clear orientation to the drawing of the real outlines and make it easier to understand the distribution of the shapes. Straight lines always suggest flat surfaces, while curved outlines create an impression of enclosing rounded bodies. By drawing the sketch with straight and curved lines, it is much easier to imagine the total shape of the body and the arrangement of the individual anatomical shapes.

The finished drawing is a convincing reconstruction of the essential features of the pose.

SKETCHES OF MOVEMENT

Skill in drawing anatomy is closely tied to the correct interpretation of a figure. The anatomical relief of each pose is the result of that movement, which creates tension and brings muscle groups into action. To achieve that, it is necessary to study very carefully the changes that occur in the various external parts of the body when an action is performed.

Rapid Sketches

The best way to acquire agility in anatomical representations is to do quick sketches of nudes. This is a mandatory assignment in most art schools. The model maintains a position for a few minutes (between five and fifteen), and then changes the pose. The students have to draw the pose as well as possible in that brief period of time and begin a new drawing immediately afterward. In order to achieve some type of result in this process, the artist has to establish the axes of movement almost instantaneously and approximate the anatomical contours in the best possible manner. The first attempts are never too encouraging, but little by little the artist will pick up manual dexterity and quickness of vision, which are the two essential virtues in this type of practice.

Rhythm of Line

One important value in doing sketches is the rhythm of line. The rhythm is marked by the alternating of strokes of different thickness, shading, and areas of white. How these factors are distributed in the sketch gives it vitality, as long as it respects the congruence of the anatomy. Lightness of line and quickness of execution are good allies for the rhythm of a drawing as long as the artist has adequate experience in anatomical drawing.

Visual Memory

Another fundamental in doing quick sketches of nudes involves developing the visual memory. The illustrator has to capture at a single glance the significant qualities of a pose—the weight distribution, the supports, the bends and twists

The key to a quick sketch is economy of medium and certainty in the basic lines of the pose. Drawings by Muntsa Calbó (left) and Joan Rasel (right).

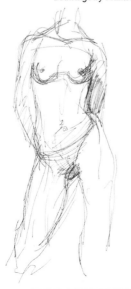

In quick sketches sometimes quantity is more important than quality. The more practice you get using hand and vision, the easier it is to reconstruct a figure from memory.

in the figure—and immediately transfer them to paper though a synthesis of lines and blocks of color. With time, the artist will be able to conceptualize a subject in any position without having to consult a model. This is the significance of a knowledge of anatomy for an artist: knowing what needs to be present and how it should look, without the need to look at a model.

Quick Layout

In quick sketches, the figure has to be very simple. There is no time to lose in fine-tuning all the anatomical areas. A leg may be represented with nothing more than a line; a back may be indicated by the furrow of the spinal column and some other quick indication; an oval will serve to represent the head.

Expert illustrators sometimes use blocks of color rather than lines for layout, that is, a quick arrangement of shadows that set up the relief in the figure through the contrast that they create with the white of the paper. This method has the advantage of explaining not only the

movement of the figure, but also the shape of the limbs.

Photographs

For illustrators who do not have access to a model, there is still the possibility of doing quick sketches based on photos of all kinds of subjects. The illustrator should be sufficiently disciplined to avoid spending more time

with the photos than that allotted for each drawing. It is best if this time is limited to ten or fifteen minutes. With time and practice, this time can be cut back to just three or four minutes to force concentration on the things that are really important.

A quick sketch is an exercise in graphic synthesis that helps memory retain the essential anatomical features. Work by Joan Rasel.

TECHNIQUE AND PRACTICE

ACADEMIC ANATOMY

The practice of anatomical drawing in art schools is marked by a special interest because of the techniques used. The traditional process has always been charcoal applied in very different ways in large formats. The usual style of these works is a very careful realism.

Academy Figures

Traditional anatomical drawings done in art academies are known as academy figures. They are commonly large format works (between three and five feet/one and one-and-a-half meters in height), done in charcoal and very attentive to detail and the modeling of light and shadow. These drawings may be representations of classical statues (frequently plaster copies of Greek and Roman originals) or of living models. The poses of the models may be maintained for days or weeks to allow the illustrators to achieve the greatest degree of finish. These academy figures may be entire figures or drawings of details: feet, hands, heads, torsos, and so forth.

Usual Techniques

The most usual procedure in doing academy figures consists of various techniques

Maria Fortuny. Frontal View of Discus Thrower. *Sant Jordi Academy of Fine Arts (Barcelona, Spain). Work done with artist's pen and India ink.*

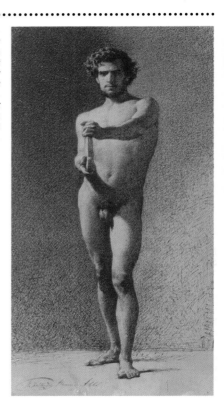

Badia Camps. Reclining Nude. *Private collection. In modern time, artists seek more direct poses and procedures for their anatomical studies.*

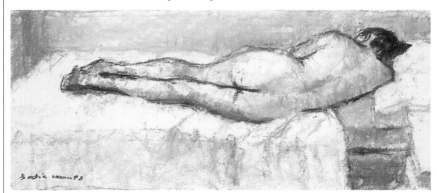

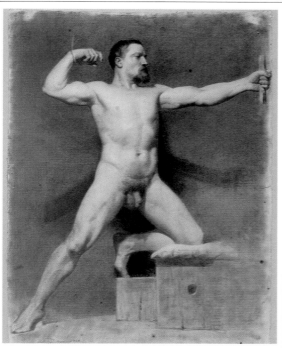

Instead of (or in addition to) using charcoal in stick form, the charcoal can be used as a powder, darkening the paper with the aid of an artist's brush or a rag dipped in charcoal dust. This technique is harder to control, but it produces smooth and airy finishes.

Other Techniques

Other techniques involve drawing with ink and an artist's pen or cane. These tools require smaller formats and smoother and tougher papers than the ones used with charcoal, because the action of the tool is much more aggressive on the paper. Colored chalks in earthy colors and combined with white chalk and charcoal are another common option that is particularly attractive because of the resulting chromatic harmony.

Maria Fortuny. Archer. *Sant Jordi Academy of Fine Arts (Barcelona, Spain). The finish of academic figures requires long hours of work in the presence of a model.*

of applying charcoal. The main technique involves shading, working with a rag and artist's stumps or blenders. The rag is used to spread out the initial areas of charcoal and create a preliminary layout of the large blocks of light and shadow; the blenders facilitate a much finer elaboration and are used in the finishing phases, which may take quite a while to complete. In addition, many artists use an art gum eraser to open up "blanks"—in other words, to erase the surfaces treated with charcoal and restore the color of the paper. The clear tones produced in these areas represent light. To reinforce the contrasts even further, the materials previously mentioned can complement one another through the use of a piece of white chalk; applied to the most important areas of anatomical relief, it emphasizes their shape.

Chiaroscuro Style

Most traditional academic studies of figures are done using the chiaroscuro technique. The backgrounds are usually very dark in order to highlight the shapes of the body in lighter shades. The darkening of the background is by no means uniform; it is a little lighter where it adjoins the darkest shading of the figure; that way the outline is visible in the darker parts as well as in the illuminated ones.

Anton Van Dyck. The Magdalene. *Museum of Fine Arts (Bordeaux, France).*

LIGHT AND ANATOMICAL RELIEF

Shapes can be appreciated only under the right lighting conditions.
Drawing anatomy involves representing the relief of the body under certain
lighting conditions. Depending on the direction of the light, the anatomical
relief takes on different characteristics; every light direction lends itself to
some artistic purpose.

Light and Shadow

The same object can appear very different according to the effects of light. The distribution of light and shadow on its surface can highlight, distort, or conceal its true shape. This fact is of tremendous importance in anatomical drawings. Our familiarity with the male and female bodies helps us properly understand their shape under very diverse conditions, but it is crucial for artists that these conditions be the best possible ones for anatomical studies.

Types of Illumination

Illumination is classified according to the position of the light source. It is therefore possible to speak of lateral, frontal, overhead, and low illumination, depending on

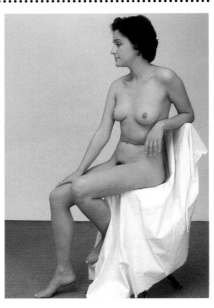

Frontal illumination tends to flatten shapes and eliminate shadows.

whether the light is located to one side of, in front of, above, or beneath the subject. Lateral illumination tends to divide the body into two nearly symmetrical halves of light and

Background Illumination

The tonal quality of the background behind the figure is of considerable importance. Ideally, its illumination should create an intermediate tone between the most intense light and the darkest

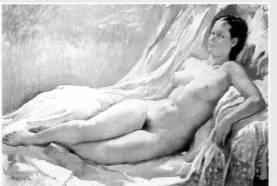

shadows of the figure so that both the light and the dark areas stand out from it. In academy figures, this problem is addressed by hanging cloths or curtains of lighter or darker colors, depending on the chosen illumination.

*Josep Puigdengolas. Nude.
Museum of Modern Art
(Barcelona, Spain).*

It is important that the illumination affect all of the anatomy to differing degrees, creating contrasts of light and shadow and reflections.

shadow, a division that is intensified when there is just one source of light. This type of illumination is very effective in setting off the shape of the anatomy. Frontal illumination nearly eliminates the shadows on the body, and as a result, it tends to obscure the relief. Overhead lighting (such as that of the sun) usually does not point up the anatomy in an interesting way, since the shadows accentuate the shapes from underneath. Finally, illumination from below produces dramatic or phantasmagoric effects that are too theatrical for most artists.

Selecting Illumination

The best way of illuminating a figure or a statue for the purpose of drawing its anatomy is to use slightly elevated lateral illumination, or to combine two light sources, one lateral and the other central. That way, the anatomical shapes remain clear and individualized, without blending together, and they are highlighted by shadows that are not hard enough to produce an unpleasant profiling effect among parts of the body. Ideally, the shaded side should receive some type of indirect or reflected light to keep the shadows from becoming totally black. To achieve this the model merely needs to be positioned next to a white surface.

Lateral illumination divides the anatomy into two parts that are clearly defined: light and shadow.

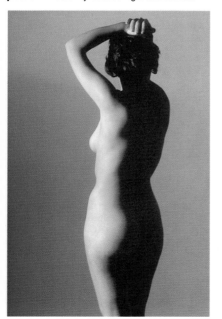

A combination of lateral and overhead lighting is the best choice for anatomical illustrations.

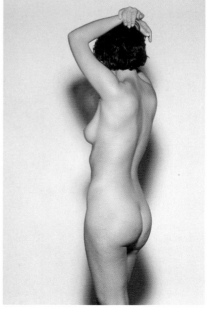

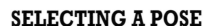

SELECTING A POSE

There is no limit to the number of poses that are suited to anatomical drawings.
Still, some guidelines apply in choosing a pose. It should combine interesting
anatomical features with fluency and an appealing artistic sense.
These are basic factors in truly artistic depictions of anatomy.

Repose

Figures in repose are the best ones for a naturalistic and detailed study of anatomy. Whether the models are standing or seated, static poses approach the classical ideal of the nude, conceived as a noble and serene construction. Statues from ancient Greece and Rome established the universal models for these poses, for both men and women. The statues of Apollo and Venus that fill classical art museums are clear testimony that there exist useful formulas for expressing dignity and nobility through anatomy. With standing figures, classical repose always presents the characteristic movement in the hips (contraposto) described on pages 62 and 63. The inclination of the shoulders is opposite the position of the hips, and this lends dynamism to the body and keeps these

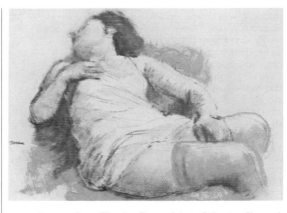

Francesc Serra. Sleeping Figure. *Private Collection. Figures in repose must avoid being overly stylized. In this example, even though the figure is asleep, there is an interesting dynamism.*

kinds of figures from appearing too stylized. The great attraction of this type of pose is that the anatomy presents a harmonious appearance from the lineal viewpoint (involving the outlines of the figure) as well as that of the shapes (the transitions between the different parts of the body).

Action

Poses involving movement always convey energy, vitality, and even aggressiveness. In this type of pose, anatomical representation must always exist in the service of one of these ideas. This renders contradictory the very detailed approach that an illustrator may use for a static pose; an excess of details nullifies the movement, freezes it, and creates an incongruous effect. The most sensible thing is to work on this type of pose with the same dynamism that it needs to communicate, using media that permit long, quick strokes and broad blocks of color. In any case, drawing action poses requires the greatest possible attention to anatomy,

Francesc Serra. Model Bending Over. Private collection. An example of an open pose in which the limbs are oriented in different directions.

equal to that of static poses, since anatomy involves a set of mechanisms designed to produce movement.

Open and Closed Poses

If we consider anatomy to be an assembly of harmonious parts, an open pose is one in which one of the parts stands out from the whole. A closed pose is one that can be sketched in simple and unified form and in which the whole take precedence over the parts. A sketch of an open pose requires more elements, more blocking in the layout sketch. Closed poses are closer to sculpture; they form a unified block. Open poses have more liberty in drawing and color.

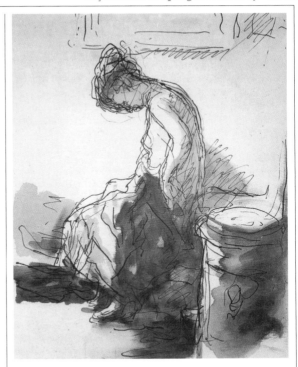

Francesc Serra. Seated Model. *Private collection. Sketch and finished drawing blend in this splendid illustration.*

The Profile

In a side view, the shape of the profile predominates: the form of the head, the facial characteristics, the trunk, the stomach, the thighs, and so forth. In many cases, all these elements can be represented using a continuous line. This is not to say that shapes and model-

ing are not important, but they are subordinated to line. If this line is sufficiently agile, it can contain enough anatomical information so that it needs only a bit of cursory attention to shading.

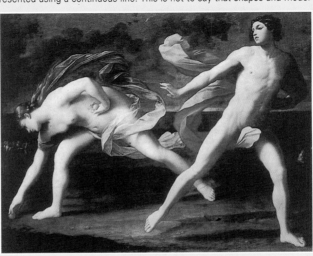

Guido Reni. **Hypomenes and Atlanta.** *The Prado, Madrid.*

TECHNIQUE AND PRACTICE

LAYOUT AND SHAPING OF ANATOMY

Above all, drawings involving anatomy are balanced representations of relief in the body. A vision of the large masses that comprise this relief is a guarantee of proper definition in the shape and size of the muscles. The distribution of light and shadow is the surest way to achieve that.

Paper and Charcoal

Drawing in charcoal makes it easy to adjust large areas of light and shadow. Charcoal facilitates broad blocks of color of different intensity, subdued by blending and erasing, in a supple and direct technique where the artist can correct and adjust the component parts of the work at any moment in the process. Charcoal does not facilitate as much detail as pencil or the artist's pen (especially in small or medium formats), and it forces the artist into an effort at synthesis where the layout of the essential blocks or shapes is what really counts. This makes charcoal an ideal process for doing anatomical

In order to create a homogenous base color, charcoal is used to darken the paper, and the strokes are blended together to create a unified tone.

drawings, because it forces attention to proportion and the harmony of the whole, rather than on the concrete details of one articulation or another.

The Drawing Process

The drawing that is done on these pages begins with a general coloring of the paper to create a uniform gray. This coloring is accomplished by spreading out broad strokes of charcoal that subsequently are blended carefully to cover the whole paper. It is possible to draw on top of this gray base with a stick of charcoal to produce strokes that are darker than the background, or with an art gum eraser to

produce strokes that are lighter than the background. In the latter instance, it is possible to create a rough approximation of the figure's entire anatomy by setting up a series of light zones that later become the illuminated parts of the body. If this layout is done correctly, the result is a very fine guide or pattern for constructing the entire figure.

Blocks of Shadow

Next it is necessary to set up a contrast between the initial light areas and the corresponding areas of shadow. These shadows must be flat, without shading, and they must create edges with the extremities of the illuminated planes. The result is an overview of more or less prismatic (i.e., not rounded) shapes that allows checking the correct proportions of each part of the subject with respect to the whole.

Once that has been accomplished, it is necessary to check the overall proportions of the figure—not only the accuracy of the figure, but also the relationship to the background. If the background is too dark, it is better to lighten it by rubbing it with a clean cloth than to force the contrast through excessive darkening of the shadows on the figure. Once a balance among the tones has been achieved, it is possible to start adding the details of the anatomy.

Selecting a Pose
Layout and Shaping of Anatomy
Line and Color in Anatomical Drawing

75

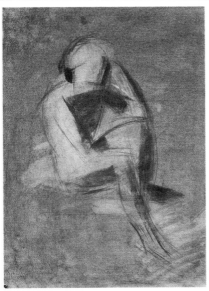

Areas of light are created by using an eraser to lighten the base color. The areas of shadow are applied with the stick of charcoal held flat against the paper.

Blending makes it possible to shade and define the articulations and the anatomical details without having to add more lines or blocks with the charcoal.

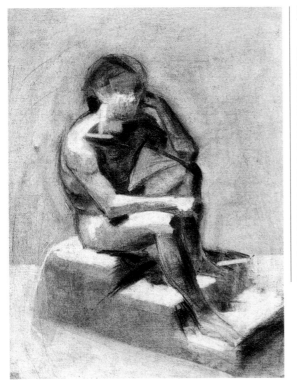

Shading

As in the beginning of the work, the final phase can also be done by drawing with the charcoal or erasing with the art gum eraser. A third possibility can be added to these two: blending. A blender is a cylinder of absorbent paper that is used to spread out and soften the areas treated with charcoal. Combined with the eraser and the charcoal, the blender makes it possible to create many different nuances of light and dark. If the initial layout has been done correctly, it will be quite simple to add the necessary anatomical features (always with reference to the model) to complete the drawing.

The final product is a coherent and synthetic vision of the whole of anatomical shapes. Drawing by Esther Serra.

LINE AND COLOR IN ANATOMICAL DRAWING

Anatomy in art is above all a means of expression. A drawing involving anatomy that is nothing more than a satisfactory representation of the objective features of a subject achieves only part of what we expect from a work of this type. The lines and colors constitute an expressive vehicle that animates and endows the anatomy with artistic sense.

Materials

Chalks are traditional tools used in drawing figures. They have a natural quality that combines the strokes of charcoal with a greater degree of precision, and they therefore are similar to soft lead pencils. The usual colors of chalks (sienna, sepia, and red) make them especially well suited for drawing nude figures, especially for the anatomical features. The process illustrated on these pages involves sienna and red chalks in combination with powdered red pigment applied with an artist's brush. These materials yield extremely attractive results and preserve the necessary accuracy in the anatomy. Applied to cream-colored paper, the lines and blocks of color take on a very warm and harmonious appearance.

Initial Areas of Color

In this technique, the drawing of the figure need not be resolved from the very outset. It can take form gradually through various adjustments and approximations that serve to give an outline to the shapes and succeed in defining the shading and the shapes of the body so that all these factors come together progressively and simultaneously. Accurate rendering of anatomical details is accomplished through successive adjustments to the shapes, the strokes, and the areas of color after comparing the relationship of certain shapes with others.

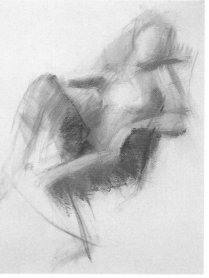

Powdered pigment applied with a brush offers an interesting possibility in drawing; it facilitates shading and gives the work an atmosphere of warmth.

The anatomical features take shape progressively and globally, without insisting on details, in seeking the important relationships between light and shadow.

Layout and Shaping of Anatomy
Line and Color in Anatomical Drawing
Anatomy and Line Drawings

77

Applying Pigment with a Brush

The pieces of chalk make it possible to draw precise lines and fill in shaded areas, and the powdered red pigment is a very adaptable resource that facilitates rapidly coloring and spreading out shading of medium intensity. In addition, the artist's brush is also useful in distributing the chalk colors in the same way that a blender would. When brushwork is combined with the art gum eraser, it is possible to construct intricate combinations of light and shadow that need only some minor definition from lines done in chalk.

In combination with these advantageous techniques, the brush produces a special warmth in the finish. It creates an atmosphere where light and shadow interlace naturally and impart life to the figure. If the artist is capable of expressing all the requirements of anatomical drawing, the warmth of this finish will endow the work with real artistic merit.

Sticks of chalk make it possible to shade using series of parallel lines that give graphic quality to the finished drawing.

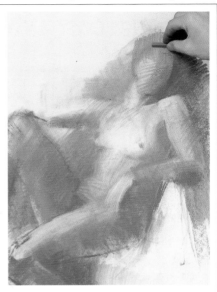

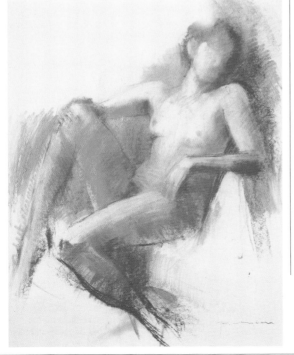

Finishing the Process

Artists who work using this and similar techniques leave the final definition of the shapes to the darkest shades. In effect, once all the shapes have been constructed in the correct proportions, they merely need to be differentiated clearly and separated using darker areas of color. These areas are applied with a stick of sepia chalk, taking care to define the precise limits that separate them from the lighter areas. In the finished drawing it can be seen how these areas define the subject's shoulders and flanks and create a dark background against which all the anatomical features stand out. The result is harmonious, without sharp contrasts, and it is unified. The body appears to be a truly organic unit in which the parts are integrated in a perfectly articulated whole.

Finally the darkest areas of color are added. In forming a contrast with lighter areas, they complete the definition of the most important outlines of this figure by Pere Mon.

TECHNIQUE AND PRACTICE

ANATOMY AND LINE DRAWINGS

Line drawings are the most precise of the drawing styles. Their precision derives mostly from the delineation of each anatomical feature and the detailed rendering of its outline. In addition, this is a flat drawing, with scarcely any effects of volume, since the representation involves the profiles of the shapes.

Abstraction

Abstraction involves representing figures and objects through lines. Lines do not exist in nature: bodies are bounded by surfaces, not lines. A line is always a sign that distinguishes and separates areas on the paper in such a way that the observer understands the allusion to a real shape. These considerations aside, the most important thing is to emphasize that a line drawing always involves greater abstraction than a shaded drawing or a painting. Greater abstraction and greater precision are needed, since the lines have to express the outlines as well as the shapes without use of shading. For those reasons, line drawing is one of the best exercises for practicing anatomical drawings.

Length of Lines

Except when a desire to create a stylized and elegant drawing takes precedence over descriptive intent, it is not a good idea to draw using long, continuous lines. Lines that are too long are very difficult to control, and they make it practically impossible to keep the proportions under control. It is far better to use short lines that form the outlines and shapes little by little and allow some leeway for adjustment. These outlines are not only exterior ones, but also interior. In its abstract quality, the line can delineate spaces inside the figure; for example, in the center of the chest, in the hips, the neck, and so forth. These interior lines make the anatomical features appear with much greater clarity and precision

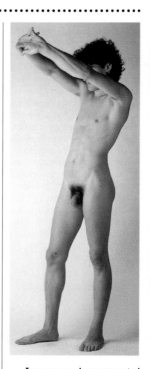

Any pose can be represented by a line drawing. In this case, the basic anatomical task involves presenting the limbs in the correct length.

Simplicity of Line

The great examples of anatomical line drawing often have one characteristic in common: the simplicity of the lines. This simplicity shows a great capacity for synthesis, in other words, the correct representation of the anatomy with the greatest economy of media. At the same time, it is a sign of stylistic elegance.

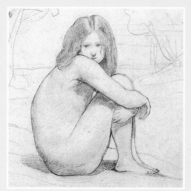

Jean-Baptiste Camille Corot. Girl in a Landscape. The Louvre, Paris.

than when only the exterior profile of the figure is drawn.

Width of Lines

It is customary to start the drawing with smooth, thin strokes and to go over them later to make them bolder. It is a lot easier to erase a faint line than a dark one, since the latter

Line and Color in Anatomical Drawing
Anatomy and Line Drawings
Anatomical Drawings Using an Artist's Pen

79

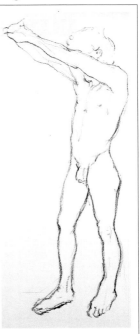

The lines of the drawing set up the outer limits of the figure and a few interior highlights necessary for a proper artistic interpretation.

instrumental in establishing the difference between the figure and the background. Although line drawings may not be as attractive as ones done in charcoal or pastels, they are surely the best for detailed anatomical studies.

MORE ON THIS SUBJECT

- Line and Color in Anatomical Drawing, **p. 76**
- Anatomical Drawings Using an Artist's Pen, **p. 80**

The first lines should be very faint and disconnected so that it is possible to correct any errors.

tends to leave a groove in the paper. The initial short, light strokes can establish an approximate layout of the anatomical features so that together they all constitute a proper outline of the body. In addition, it is difficult to capture the entire outline of the model all at once through observation. It is necessary to keep referring to the body in order to put together a representation piece by piece.

The Final Product

Once the anatomical features have been resolved, some of the lines can be touched up to lend a slight suggestion of volume to the drawing. It makes sense to go over the outer profile and leave the interior lines less pronounced, since they are not

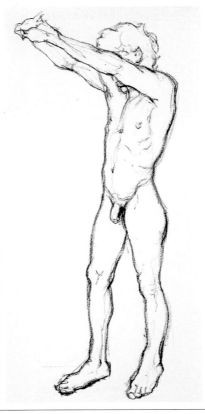

To conclude, it is a good idea to touch up and thicken the exterior lines so that the drawing seems to have more volume. Drawing by Vicenç Ballestar.

ANATOMICAL DRAWINGS USING AN ARTIST'S PEN

The artist's pen is probably the most precise conventional means of drawing. It allows very pronounced definition of shape and is the most demanding one, since it contains no margin of error for making corrections. The pen can be used to create very attractive anatomical drawings, though.

Colored Inks

It is customary to use black India ink when drawing with an artist's pen. India ink is very opaque, slightly glossy, and intense in color, and it covers well. It can be diluted in distilled water to create intermediate shades, even though it is a bit unstable and does not produce uniform grays, but rather washed out hues. There are also some very brightly colored inks. Even though they are used much less frequently than India ink, they are a good complement to it in subjects such as the human body.

Format and Technique

Drawings done in pen cannot be very large, because the lines are very fine, and the only way to create shading is to multiply the lines to create a mesh or dense crosshatching of limited extent. In addition, the need to reload the pen frequently interferes with continuity in the lines, and this lack of continuity would detract from the finish of a large format drawing. The drawing paper has to be smooth, without grain or texture, so that the pen glides across it easily.

With a lot of practice in drawing with pen, it is possible to start drawing directly in ink. In order to avoid problems, however, it is a good idea to do a preliminary sketch in pencil before using the pen.

Light and Shadow

The pen is a "harder" medium than either pencil or pastels; the lines are clearer, finer, and more precisely defined, and they can be attenuated or blended with others. The transitions between shapes are always more abrupt. That can be an advantage when a clear and well articulated anatomical representation is desired.

Here is a preliminary drawing done in pencil; the illustration resolves nearly all the issues involved in the articulation of the pose.

This illustration shows how the outline is much darker than the fine lines that begin to shade the figure's side.

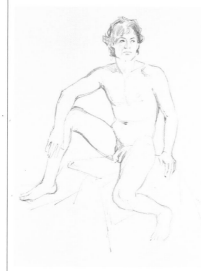

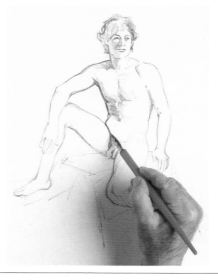

Anatomy and Line Drawings
Anatomical Drawings Using an Artist's Pen
Studies in Light and Shadow (I)

81

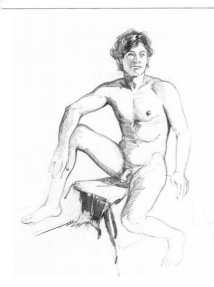

Ink in a shade of orange is used for the figure. India ink is used for the base on which he is seated. The latter is diluted with water to produce areas colored with lighter ink.

Finishing the Drawing

Little by little, as the cross-hatching of fine lines accumulates, the shapes of the limbs begin to round out. In the left thigh, the slight diagonal protuberance of the sartorius muscle is visible.

Once the drawing of the figure is complete, you have to erase the lines left over from the initial pencil sketch so that the work will appear clean. One of the major advantages of drawing with pen is that it allows creating the tiniest details with great precision and clarity; at the same time, it facilitates control of shading through the use of cross-hatching. The final result is a perfectly constructed and proportioned drawing in which every anatomical feature is rendered accurately and integrated into a harmonious whole.

Developing the Work

Drawing with a pen has quite a bit in common with using a pencil, such as fine, clean lines and shading done with crosshatching. Just the same, the pen does not allow graduating the darkness of the line: all lines have the same intensity. This makes it necessary to keep tentative lines to a minimum and be sure that every line is correct. It is important to start with a complete pencil drawing that resolves practically all the formal issues involved in the pose; the ink will subsequently redefine and make them permanent. Once the pencil sketch is completed, the artist can begin using the pen to trace the basic lines of the figure without pressing hard on the paper. The more pressure is used, the thicker the line. As the drawing progresses, lines can be added with colored ink (orange, sepia, and red diluted with water) to diminish the coldness of the uniformly black lines in India ink.

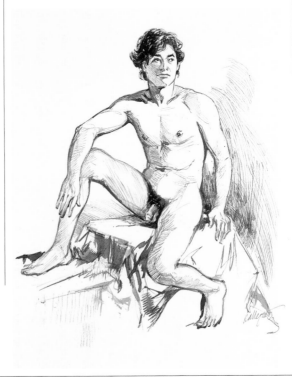

The end result is a perfectly constructed and proportioned drawing in which every anatomical feature is rendered accurately. Drawing by Vicenç Ballestar.

STUDIES IN LIGHT AND SHADOW (I)

A study of the interplay of light and shadow in the human body amounts to an analysis of the constants of anatomical relief. Light and shadow highlight the muscular features, and proper shading is closely connected to a knowledge of anatomy.

A Basic Study in Charcoal

Charcoal is the simplest process for drawing, and it is also the best choice for studying the basic interplay of light and shadow on anatomical representations. The sequence illustrated on these pages is an exercise in shading with charcoal. Its purpose is not a detailed depiction of every feature of anatomical relief, but rather a synthesis of the shapes of the body.

The work begins with a general outline of the pose. This layout is a synthesis created with just a few lines that suggest a generic outline. There's no need for small, accidental features in the silhouette. You have to remember that the objective of this drawing is a general shading, somewhat like a layout sketch with added shading, that has value unto itself even though it may be subject to detailed elaboration. The initial drawing should therefore not be too detailed.

The Initial Shadows

Shadows are added immediately to the drawing. Adjusting the lines also involves adjusting the appearance of the shapes, and consequently, light and shadow. The breadth of some lines already provides a clue to the illustrator as to which areas need shading.

Using the stick of charcoal flat against the paper, with light pressure, a few broad strokes are applied to cover the side of the neck and

The drawing correctly laid out using outlines that define the anatomical features with simple shapes.

The first shading should be extended and blended using a clean cloth.

shoulder as well as the darkest areas of the trunk and the legs. Pressure on the charcoal must be very light to avoid areas of excessive darkness. It is always a lot easier to darken than to lighten, since lightening in one way or another involves erasing and the possibility of soiling the illustration.

Anatomical Drawings Using an Artist's Pen
Studies in Light and Shadow (I)
Studies in Light and Shadow (II)

83

Depicting Shapes

The sole purpose of adjusting light and shadow is to create shape and volume. In the exercise presented on these pages, the shapes are reduced to their generic form. As a result, the shading should be limited to underlining the shapes of these basic components.

The thighs are cylindrical spindles similar to ones that we encounter on an articulated mannequin. Similarly, the trunk is a fairly smooth piece, and its shading should be consistent with this simple form.

Once the necessary areas have been shaded, they are rubbed with a clean cloth in order to unify the shading and spread it out to create a smooth transition from the white of the paper to the color of the charcoal.

An art gum eraser makes it possible to control precisely the shape of the shaded areas.

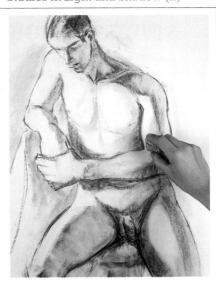

Nuances

Once the general shading has been accomplished, it is easy to avoid possible inaccuracies in the drawing that would create an impression of deformity. In addition, the simple initial areas of color provide the best guideline for later work in creating nuances in each anatomical area: elbows, clavicle, knees, calf, and so forth. Creating nuances involves adjusting the grays of the shading, comparing them to one another, darkening them as necessary to accentuate a shape, and lightening them to soften a transition. This final work should not be rushed. A union of simple and harmonious shapes is preferable to a clump of overworked shaded areas.

The final product is a synthesis of anatomical features that involves a basic study of light and shadow. Drawing by Esther Olivé.

TECHNIQUE AND PRACTICE

STUDIES IN LIGHT AND SHADOW (II)

As a continuation of the theme in the preceding pages, we will now complete
a drawing in which the treatment of light and shadow is more detailed,
involving an accurate rendition of anatomical relief. This is a charcoal drawing
of a muscular back.

Layout

This exercise involves drawing a back with pronounced musculature that is accentuated by oblique lighting that clearly shows the relief in the shoulders and the furrow of the spinal column. The lifted arms and their effect on the shape of the shoulders is one of the most interesting features of this pose. The drawing is done in charcoal with red highlights.

The initial sketch is constructed using quick strokes that define the outline of the figure and the basic anatomical features: the fold of the shoulder and the spinal column.

Once the general orientation is established, the intensity of the lines can be attenuated by going over them with a clean cloth. That preserves the remainder of the

A preliminary drawing of the outline that establishes the external features of the figure.

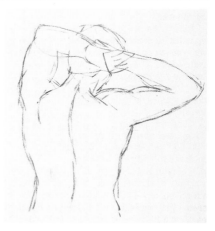

drawing, but the charcoal cannot dirty or hinder the work that follows. The leftover trail of the charcoal lines is useful in doing a much more accurate drawing that contains the most important anatomical features.

Initial Shading

The first shading is done using light, parallel strokes with a charcoal pencil. At this time there is no need to bear down with the pencil, and the hues should be kept fairly light. The darkest shadows are

The initial very light shading gives an approximation of the anatomical relief.

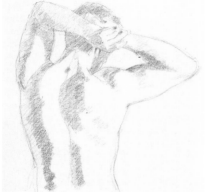

The charcoal pencil is used to darken the shaded areas and accentuate the shapes.

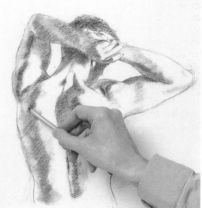

Studies in Light and Shadow (I)
Studies in Light and Shadow (II)
Shaping the Anatomical Features

85

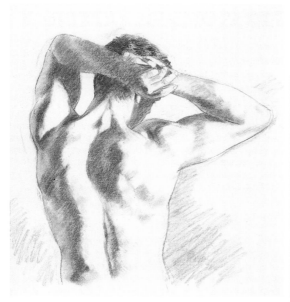

The impressive shape of the back is resolved through a careful study of light and shadow on the muscular relief. Drawing by Ferran Sostres.

color. The relief in the shoulder is almost completely defined; now the task involves highlighting the light areas of the figure by darkening the paper with pencil strokes in red.

A few simple strokes in the background serve to set up a contrast with the illuminated parts of the body. Finally, a stick of white chalk is used to lend greater liveliness to the light on the back, highlighting the most important contrasts in the anatomical relief. In the finished product the anatomy of the back stands out vividly because of restrained but effective shading.

added on top of the lighter ones. The modeling should be done a little at a time with a clear vision of the whole. To spread out and unify the shaded areas, you can use a blender, which is a customary tool in charcoal drawing. By rubbing the blender on existing shaded areas, you blend the individual strokes together and darken the entire shading.

Another common tool used in charcoal drawing is the art gum eraser. It is not just for erasing errors, but also for creating light accents between dark areas, profiling the limits of the shaded parts, and accentuating the contrast between light and dark areas.

Anatomical Details

At this point, the work is fairly homogenous in appearance. From this point on it is necessary to reinforce the shading and add nuances to highlight all the anatomical features. The left side of the figure needs to be darkened more. The charcoal pencil is used for this, using light, parallel strokes that accumulate and gradually intensify the

Charcoal in Anatomical Drawings

Traditionally, charcoal has been the most commonly used medium for anatomical studies. These studies have also been a reason for choosing complex poses filled with muscular tension in which the artists can display all their knowledge.

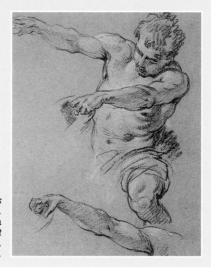

Francois Boucher. Study of a Nude. Fort Worth, Texas.

SHAPING THE ANATOMICAL FEATURES

Giving shape to the anatomical features is a natural consequence of studying light and shadow. Modeling involves analyzing light and shadow and rendering them in all their details. In this exercise, colored chalks are used in bringing an illustration to completion.

A Complete Anatomical Study

This exercise involves illustrating a masculine figure in a pose that is interesting anatomically. The figure holds his arms up to reveal their backs, the arm pits, and the elbow joints. The relief in the torso, the hips, and the legs is also very evident. The relief of the thoracic cage is clearly shown in the extension of the pectoral muscles and the *latissimus dorsi*, which in turn highlights the *serratus* and the oblique muscles. In short, this is a complete exercise in anatomy for artistic purposes.

The extension of the arms produces a series of muscular effects in the shoulders and the trunk. The relaxed position of the rest of the body allows for a study of the normal anatomical features of the muscles in the hips and legs.

Proportions

The initial sketch has set up the proportions of the figure on the basis of eight partitions (that is eight heads). The result is a robust figure with a small head. In reality, the artist has foreseen that the head will increase in size during the drawing process until it conforms to the canon of seven and a half heads. After making sure that the general pro-

portions are correct, the artist creates the relief in the outlines and the general distributions of the muscles in the arms and torso.

Preliminary Shading

The initial overall shading in sepia allows for laying out all the lights and shadows, and for addressing all the variations with a single shade of color. Just one color is needed to create a convincing anatomical representation of the entire frontal plane of the figure and the complex shape of the torso, in which the pectorals, the oblique muscle, the *rectus abdominis*, and the

The basic shapes are created by adding the shadows of the musculature in the torso and the legs.

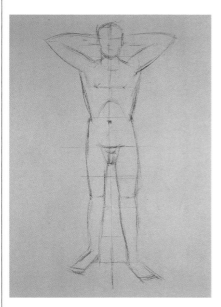

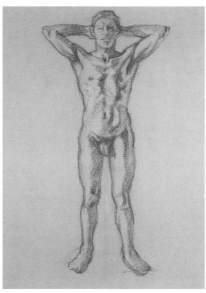

For the frontal view of a standing figure, it's a good idea to check the correctness of the proportions based on seven and a half heads.

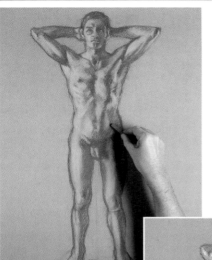

The darkest shades and the illuminated areas of the basic shape are intensified.

Divisions and Proportions

The device of using seven and a half heads can of course be used only in dealing with a figure that is standing fully erect. If there is going to be lots of shadow in the drawing, the head will increase slightly in size during the shading process.

serratus muscles stand out. The blender can be used to spread out the colors and continue shaping the intermediate areas, thereby maintaining the value of all the lines and shadows in the figure.

Shaping the Features

The illuminated areas are colored in light orange, which contrasts vividly with the earthy colors of the overall shading. This sets up the basic contrast in the shapes established by light and shadow. Reds are used to highlight the transitions between the darkest shadows and the lighter shades, but only in the darkest parts of the body —in other words, in the right side of the illustration. In order to create the light on the illuminated side, white is applied to the most prominent shapes of the body: the biceps, the bulges of the deltoids that surround the arm pit, the

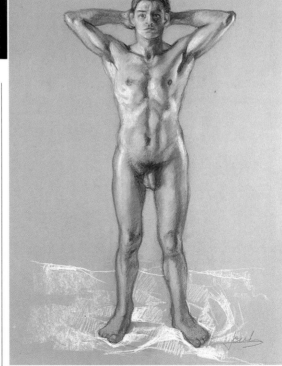

A three-dimensional result with great visual impact is created by softening the most abrupt transitions between light and shadow. Drawing by Miquel Ferron.

serratus muscles, the upper part of the *rectus abdominis*, the oblique muscle in the hips, and the tensor of the *fasoia lata*

in the upper part of the leg. This drawing constitutes a complete exercise.

ANATOMY AND CHIAROSCURO

Chiaroscuro is especially well suited to studies involving human anatomy.
Strong contrasts of light and shadow highlight all the features of anatomical
relief in the clearest possible way. The following exercise is a chalk drawing that
is rich in contrasts.

Outlines

This exercise is done in colored chalk. The colors belong to the spectrum of the earth: red, sepia, and ochre, which are complemented by white and black in order to accentuate the contrasts. This is a technique of drawing in color that allows for truly graphic effects, and especially for a great number of nuances in light and shadow. The initial drawing is based on the outline of the figure. The outline itself communicates a lot about the figure's anatomical features, especially if the model is very muscular, as in this case. The lines are not restricted to defining the outer contours of the figure, for they also contribute to delineating the borders between light and shadow in the head and trunk. These indications are very useful in determining the subsequent shading.

Shadows

The general shading is done using a piece of sepia-colored chalk and drawing a multitude of lines in the darkest areas and retouching the intensities of the "crests" of shadow that separate the lightest parts from the darkest. This process is facilitated by the lines of the preliminary sketch. The darkest areas have to be covered with a uniform hue to make the anatomical relief visible. At this point the artist needs to master the features of masculine anatomy, which are very evident in this pose: the relief of the ribs in the thoracic cage, the muscular shape of the arm pit, the flexion of the legs, and the relief in the knee cap.

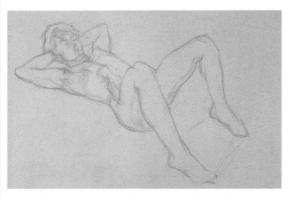

The preliminary sketch is based on the irregularities of the subject's outline, plus a few indications of the interior shapes.

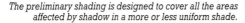

The preliminary shading is designed to cover all the areas affected by shadow in a more or less uniform shade.

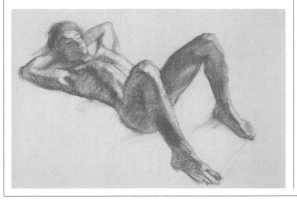

Contrasts

In order to emphasize the contrasts even more, lighter shades are added to the illuminated areas. These involve using ochre and yellow. The contrast created is much more intense, and it comes close to the foreseen objective of setting up a strong chiaroscuro. The sheet on which the figure appears is shaded in gray at the same time, and it is distributed to suggest the wrinkles. Accentuating the illuminated areas practically completes the drawing with

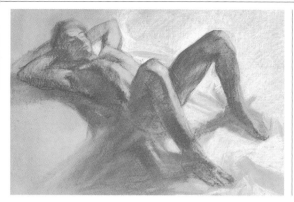

to gradually darken the areas that require this treatment.

Finally part of the background is covered with a network of strokes in white to evoke the illuminated parts of the sheet and its wrinkles.

The highlighting of the illuminated areas is accomplished using ochres and yellows.

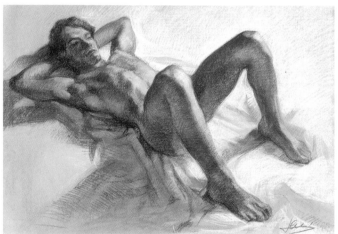

Finally, the chiaroscuro is emphasized using charcoal, and the background is covered with whites and grays. Drawing by Miquel Ferrón.

respect to the anatomical features.

Chiaroscuro

Once all the questions about modeling and highlighting have been resolved, it is time to intensify the shadows to create a real effect of chiaroscuro. A stick of charcoal is used to darken all the shaded areas and accentuate the most significant anatomical features. These include the armpit, the shape of the face, the elbow, the thorax, the knees, and the calves. These shadows are created with interlacing strokes that form a dense mesh of lines. You can make this mesh even denser

Anatomy and Baroque Chiaroscuro

During the Baroque period many painters used the dramatic effects of chiaroscuro to emphasize every individual feature of anatomy. The most dramatic example of these painters was José de Ribera, who achieved brutal effects of contrast between highly illuminated bodies against a completely black background.

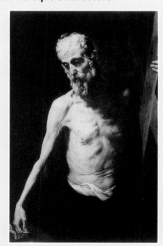

José de Ribera.
Saint Andrew.
The Prado, Madrid.

HARMONY IN ANATOMICAL RELIEF

Watercolors are the graphic procedure that provides the smoothest and most delicate results. When they are used in illustrations involving anatomy, they require a synthesis of muscular relief that avoids an abruptness of appearance that would contradict the nature of this attractive procedure.

A Good Preliminary Sketch

The great subtlety that watercolors make possible is coupled with a great difficulty in making corrections. Therefore, each brushstroke has to be accurate and certain, and once the coloring has been started, the process has to be finished with scarcely any room for changes. This means that the initial sketch has to be done as well as possible, and you have to work on it as much as necessary before coloring it in. In this exercise, the preliminary drawing has been done in charcoal. It is possible to erase and correct charcoal easily, and this procedure holds another important advantage for the watercolorist: once the drawing is finished, the lines can be erased almost completely with a cloth; the paper will retain scarcely any traces of the drawing, but they will be adequate for painting over without tainting the colors.

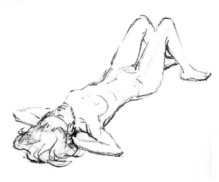

The charcoal drawing must be done correctly. Then it is erased with a cloth to keep excess charcoal from soiling the painting.

Washes

Washes involve using watercolors diluted in water to cover large areas. These large areas of color make it possible to cover broad areas of paper in the early stages of work in order to check the general effect of the color tones. Washes require the use of a fairly thick, flat brush. The wash can be applied by first moistening the area of the figure with clean water and then applying a little color, which will spread out uniformly when it contacts the damp paper. This creates a layer of base color, a general shade that makes it easier to harmonize the other colors. The base color should be a warm one such as an ochre or a brown.

Begin working on paper previously moistened so that the areas of color blend together.

Final touches are applied to the hair and the darkest areas.

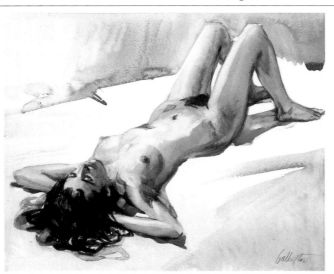

The final product is an anatomical study done in transparent colors in perfect shades. Watercolor by Vicenç Ballestar.

Modeling

The first modeling of the figure is easy when you are working on moistened paper: the colors blend with one another, and the transition between light and shadow turns out smooth and gradual. While the paper is damp, darker shades can be added little by little to create the general shape of the figure. The subtle layers of color give a special delicacy to works done in this way. Anatomical features can be depicted very effectively, since in reality the body is a continuum of surfaces that transition smoothly from one to another.

Finishing the Work

The last touches of watercolor are applied to the paper when it has dried. These details must be done in fairly diluted colors to keep the new brushstrokes from looking like blotches of color. These new brushstrokes are dark shades intended to produce greater contrast in different parts of the drawing. This last phase involves creating the curls in the hair, the shadows on the sheet, and the shading on the breasts and thighs.

Watercolors and Anatomical Studies

Even though watercolors are not the most common medium for anatomy in art, they have a distinct advantage that separates them from the other media. Because anatomy is based on areas of color, it appears like a continuum, and the body, with all its muscular relief, turns out nicely unified.

*William Orpen.
The Model.
Tate Gallery, London.*

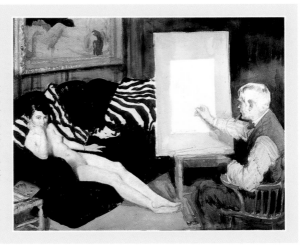

LIGHT AND COLOR IN ANATOMY (I)

Pastel painting may be the best vehicle for depicting the human body in a setting
by using light and color, above and beyond the objective representation of muscular
relief. In the exercise illustrated on these pages, you will see how a pastel painting is
done so that strict anatomical preciseness is softened by a sensitive use of color.

Pencil Drawing

Even though most artists working in pastels begin their works directly in color, in this case the sketch of the figure is first done in pencil. The drawing contains not only the general outlines of the body, but also some hints of transitions between light and shadow. Once that has been completed, a generic color is chosen to serve as a color base for the work. This color may be red, which will provide the tonalities of the subject's skin. A colored drawing is not simply a line drawing of contours; it includes areas of color and suggestions of volume. This is a drawing that will make possible a confident expression of the light and color that will dominate the work.

Color Contrasts

The red hue of the drawing suggests a work based on contrasts of color more than on those of chiaroscuro. The following color applications include shades such as yellow and red-orange. These are very lively and warm hues that are effective in depicting both a well-lighted scene and strictly anatomical features. These colors are distributed in the work according to the logic of lights and shadows—a logic that sometimes takes precedence over precise anatomical representation. The artist has to look for a com-promise between these two requirements to satisfy the necessary fidelity to anatomy without sacrificing the very sensual and fleeting hues.

Harmonizing

One danger in this type of interpretation of anatomy, in which color becomes more important than any other consideration, is that the form may lose firmness and a sense of unity and dissolve into a

All the basic anatomical features have to be resolved in the initial pencil drawing.

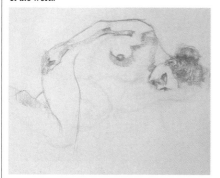

After the first pencil drawing, a reddish color is used to create the lineal and chromatic foundation of the work.

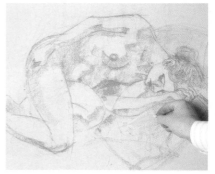

The chosen color spectrum centers especially on the reds and yellows, plus blues and greens.

Harmony in Anatomical Relief
Light and Color in Anatomy (I)
Light and Color in Anatomy (II)

93

Color of the Paper

Pastel painting is usually done on colored paper. The exercise on these pages was done on gray paper that attenuates the force of the contrasts and unifies the colors of the work. Artists should select the paper based on their favorite colors.

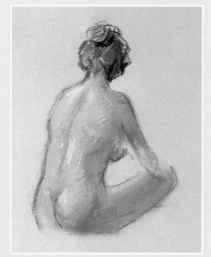
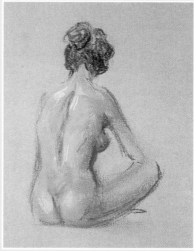

The color of the paper has a major impact on the colors used for painting the body.
Works by Vicenç Ballestar.

clump of excessively bright hues and contrasts. To avoid this, the artist has to choose a limited spectrum of related colors, in other words, ones that do not contain many strong contrasts. The choice in this work is very warm, and is centered on red. That way, even though the individual colors may be quite bright, when they are used together they complement one another and make it possible to create a sufficiently realistic representation that is rich in suggestion and atmosphere.

Finishing

Finishing the work is like a natural continuation of the process of accumulating areas of color and contrasts. Once the colors have been applied in the proper amounts, the figure takes on a special

fullness, and this is the right time to cease working on it. The body is completely defined and submerged in an atmosphere of light and color that is rich in reflections and delicate hues, slightly veiled shading, and very attractive subtleties.

The finished work is an attractive synthesis of light and color.
Work by Joan Raset.

LIGHT AND COLOR IN ANATOMY (II)

With oil paints it is possible to arrive at a more complete synthesis of light and color in any artistic theme, and that is especially true for depictions of the human body. This synthesis artistically unites the descriptive virtues of drawing, the techniques involving light and shadow, and the sensual quality of color.

Pictorial Synthesis

In this last exercise we will demonstrate the virtues of oils in dealing with the human body. Because of their density and richness, oil paints make it possible to unite all the factors of drawing, assessment, chiaroscuro, and luminosity in a single plastic medium.

Each of these factors is reflected in the work's different stages of construction. The first of these stages is, of course, a sketch of the figure. An anatomical drawing for the purpose of painting with oils needs to be a unified whole, preferably an uncomplicated mass in which not too many details are indicated, since these details will be conveyed by the colors chosen. Normally, artists use charcoal for this preliminary drawing, even though some prefer to draw in dark paint (usually red) very diluted with thinner.

Anatomy and the Atmosphere of the Nude

Every competent anatomical representation necessarily involves a specific figure and space. In a purely representational treatment of the body, this space has to contain a suggestion of atmosphere so that the figure does not appear to be frozen or dissected.

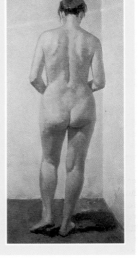

In this work, the perfect rendition of the body is accompanied by a strong suggestion of atmosphere. Work by Badia Camps.

Coloring

Coloring involves quickly covering the various areas of the composition with fairly diluted colors to try out the effect of the colors and the balance between light and shadow of the illumination. This is the stage when the artist's ability to synthesize and mastery of anatomy really become evident. A quick distribution of paint on the canvas should give an idea of the anatomical features as a unified whole, without marked differentiation among the individual parts. If this distribution is accurate, the shape of the figure will be convincing, and the values of light and shadow will be established correctly. The initial coloring must be applied in accordance with the basic contrasts of light and shadow that give sense to the anatomical relief.

The preliminary sketch done in charcoal must be very synthetic and devoid of excessive details.

Coloring the work starts by applying very diluted colors to the large areas of the work.

Anatomical relief begins to take shape as diluted colors are applied individually.

Modeling and Adjusting Color

If the foregoing phases of the work have been done correctly, further development is a function of continuing to work with colors: establishing contrasts that more effectively convey volume, and adjusting hues to create a satisfactory representation of light. The colors that set up the anatomical relief sometimes have to yield to the shadows that the body projects. The figure is set on a white surface; as a result, the reflections will be very bright and will have scarcely any effect on the skin. The color accumulates as the work progresses. It creates nuances in surfaces and reinforces the layout, plus it highlights or softens the shadows. Finally, the work acquires all the sensuality that can be expected from an oil painting. The drawing has been totally subsumed into the painting, and light and color are in harmony with the body.

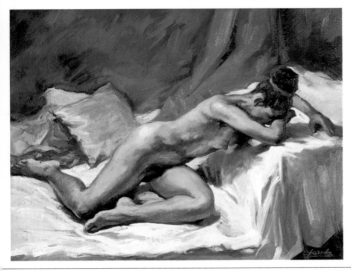

The figure progresses as colors are refined and darkened. Work by Miquel Ferron.

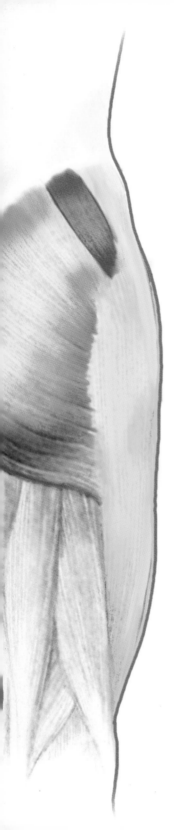

English-language edition for the United States, its
territories and dependencies, and Canada published 2002
by Barron's Educational Series, Inc.
© Copyright of English-language edition 2002
by Barron's Educational Series, Inc.
Original title of the book in Spanish: *Anatomía Artística.*
© Copyright 2001 by Parramón Ediciones, S.A.—
World Rights
Published by Parramón Ediciones, S.A., Barcelona, Spain

Author: Parramón's Editorial Team
Illustrator: Parramón's Editorial Team

All rights reserved.
No part of this book may be reproduced in any form, by
photostat, microfilm, xerography, or any other means,
or incorporated into any information retrieval system,
electronic or mechanical, without the written permission of
the copyright owner.

All inquiries should be addressed to:
Barron's Educational Series, Inc.
250 Wireless Boulevard
Hauppauge, NY 11788
http://www.barronseduc.com

International Standard Book No.: 0-7641-5355-2

Library of Congress Catalog Card No.: 2001094801

Printed in Spain
9 8 7 6 5 4 3 2 1

Note: The titles that appear at the top of the odd-numbered
pages correspond to:

The previous chapter
The current chapter
The following chapter